TAKE THREE COLOURS

WATERCOLOUR
SNOW SCENES

Start to paint with 3 colours, 3 brushes and 9 easy projects

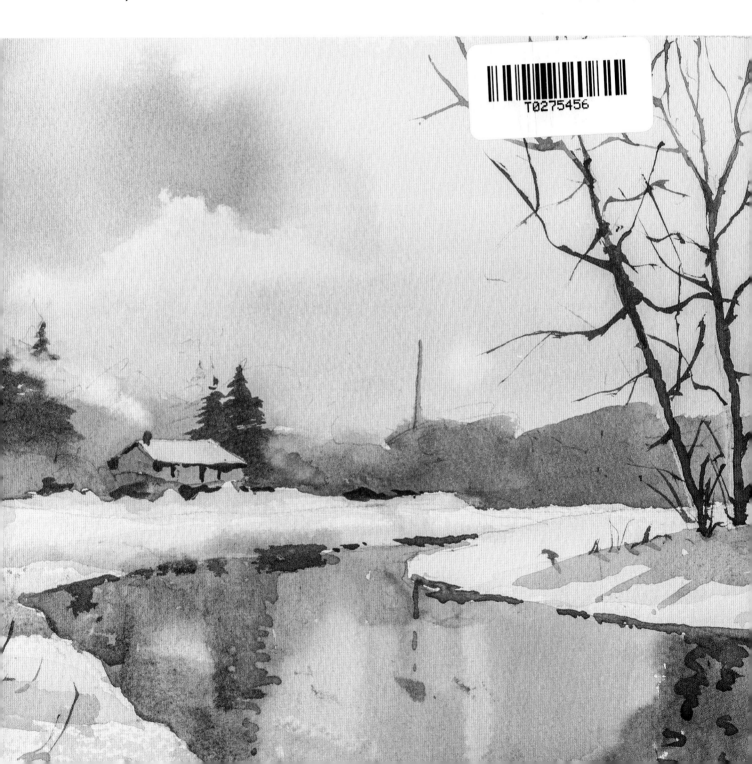

TAKE THREE COLOURS

WATERCOLOUR
SNOW SCENES

Start to paint with 3 colours, 3 brushes and 9 easy projects

Grahame Booth

SEARCH PRESS

First published in 2021

Search Press Limited
Wellwood, North Farm Road,
Tunbridge Wells, Kent TN2 3DR

Reprinted 2021

Text copyright © Grahame Booth 2021

Photographs by Mark Davison at Search Press Studio

Photographs and design copyright © Search Press Ltd. 2021

ISBN 978-1-78221-699-5

eBook ISBN 978-1-78126-628-1

The Publishers and author can accept no responsibility for any
consequences arising from the information, advice or instructions given
in this publication.

Suppliers
If you have difficulty in obtaining any of the materials and equipment
mentioned in this book, please visit the Search Press website for details
of suppliers: www.searchpress.com

To see more examples of the author's work, please visit:
www.grahamebooth.com

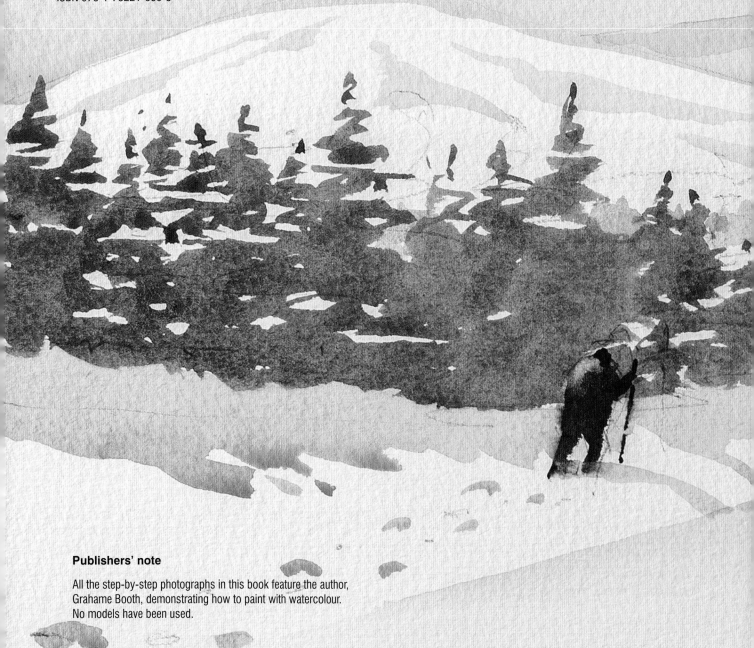

Publishers' note

All the step-by-step photographs in this book feature the author,
Grahame Booth, demonstrating how to paint with watercolour.
No models have been used.

Contents

Introduction

Modern life can often feel unnecessarily over-complicated, but with *Take Three Colours: Watercolour Snow Scenes* I am going back to basics. And I really mean it. Painting in watercolour is rarely improved by getting complicated; an unfussy application of washes helps to keep the paint fresh and transparent – two essential attributes for a successful outcome. This pared-back approach can usefully be extended to your painting materials, too. I often see students with paintboxes filled with twenty or thirty colours, many of which are rarely if ever used, and most carry many more brushes than I would ever use. In this book, I have reduced the equipment to the bare minimum so that we can concentrate on the painting.

You will soon come to realize just how many different mixes are possible from three colours, and with only three brushes you will discover just how versatile each can be. *Take Three Colours* is not a gimmick. Three carefully chosen colours can provide almost any hue you need; I well remember that when I was learning to paint in watercolour, some of my better efforts were painted with just one colour and a couple of brushes. If you are a beginner, you will discover that anything that makes painting easier to understand is invaluable, while getting to grips with the possibilities of three colours is infinitely more straightforward than coping with a full box.

Good paint and brushes are not cheap, but it is much better to invest in a small number of quality items rather than a large number with questionable performance. Paper, too, is important and there is no doubt that paper from a reputable manufacturer is usually much easier to paint on than paper from an unknown source. I suggest that you use paper with

a slight texture, known as NOT or cold-pressed, with a weight of at least 140lb/300g. You will notice that these numbers are not equivalent. 140lb refers to the weight of 500 sheets, whereas 300g is the weight of a square metre. I used Millford paper from St. Cuthberts Mill for all of the paintings in the book, but paper from any good-quality brand will work well.

Try to paint the projects in the order they are presented, as we will use techniques explained in the earlier paintings as we paint the later examples. It would also be a good idea to read through each project before you begin so that you are prepared for each stage.

Over more than twenty years I have travelled all over the world teaching beginners as well as more experienced artists, and in those couple of decades I cannot recall a single time when making the process more complex helped the painting. So get those paints and brushes ready, fill up your water container and let's have some fun!

Using the colours

The three colours I have chosen for all of the paintings are **cobalt blue**, **Winsor red** and **quinacridone gold**. These colours represent the three primary colours – blue, red and yellow – but the particular hues of these colours make them especially suitable for snow scenes.

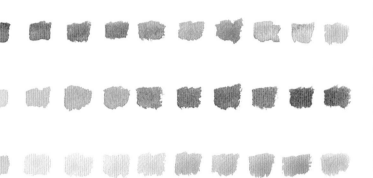

Mixing colour

Theoretically any colour can be mixed from the three primary colours. In practice this is not quite true as paint pigments are not optically pure, but you can see from these swatches that we can get a very acceptable range of hues by intermixing any pair of colours. It is very useful to try this yourself. Start with a pool of any colour, paint a square, then add a little of a second colour, paint another square and continue this process until your mix is almost purely the second colour. This will produce a colour chart that will be a very useful reference. Adding the third colour to any mix of two will tend to neutralize or grey the colour. This, too, is useful – we won't always need bright colours.

Adding water

In watercolour, we add water to the colour to create a lighter colour, or tint, and you will need a variety of these tints in the paintings. Bear in mind that it is very common to create mixes that are rather too light. Remember that the pool of colour in your mixing tray or palette will appear much darker than a thin film on your paper, and to add to this problem, your wet film of paint will dry lighter. The slightly flippant advice 'if it looks right when it's wet then it's wrong' is actually very true. Experiment using very dilute mixes (see left); running paint is nothing to be afraid of (as you'll see throughout the projects!)

In addition to water for mixing my washes and cleaning my brushes, I keep a small spray bottle of water to hand (see right). I'll be using this for the Snowy Sunset project (see pages 38–45).

JARGON BUSTER

A **wash** is simply a mixture of water and paint – the more water in the mix the weaker the wash.

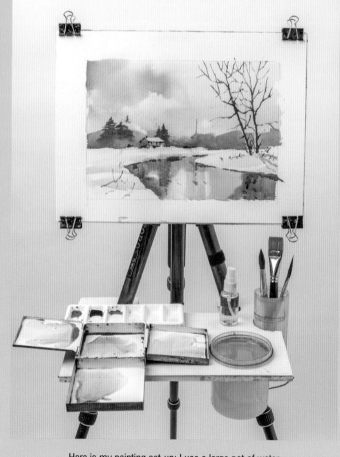

Here is my painting set-up: I use a large pot of water and deep palette for creating very wet mixes.

Using the brushes

The choice of brushes is a very personal decision but I have picked these three because they offer very different properties rather than just being different sizes. The three are: a 1-inch (2.5cm) flat goat-hair wash brush, a size 14 sable/synthetic round brush and a ¼-inch (6mm) sable/synthetic swordliner.

1-inch wash brush

Goat hair is quite soft and holds plenty of water, making it ideal for applying washes. It can also make a variety of marks: use the brush flat to create broad strokes; the edge gives very narrow strokes.

Size 14 round

It is very important that your round brush tapers to a very fine point, as it is the fine point along with the broad body of the brush that makes it so useful. This brush will be used for the majority of each painting.

Swordliner

This brush has a very long, tapering point. As well as its original function as a lining brush, this is also particularly good for winter foliage and so will be very useful for our snow scenes.

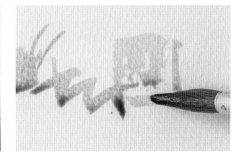

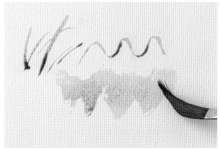

Using a dry brush

Drybrush technique is an essential skill in watercolour. Drybrush gives a rough, broken stroke, completely different to the smooth wet stroke that is so important in achieving even washes. A drybrush stroke is simply one created from very little paint and there are a few ways this can be achieved. As the name suggests, a brush with very little paint will make a drybrush stroke (see bottom image, right) but so will a slightly fuller brush but with the stroke made quickly. Generally, I use a sideways motion of the brush as shown in the top image, right. Brushes are not designed to release paint from the side and so a drybrush effect occurs even when the brush is quite loaded.

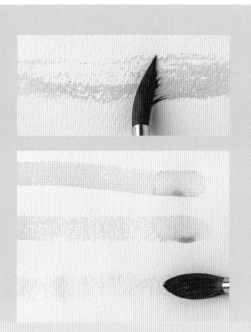

Snowy Field

What you learn:

- **Wet-in-wet painting**
- **Wet-on-dry painting**
- **Scraping out**

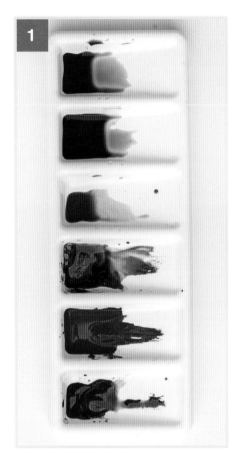

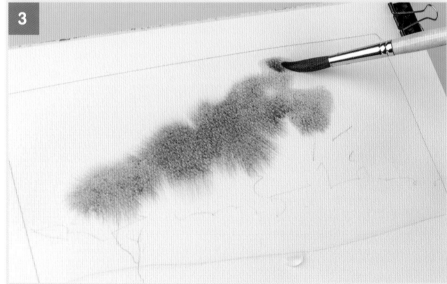

1 Use the finished painting on page 15 and the tracing guide on page 64 to transfer the outline to your paper. Secure your paper to your board. For this, and all subsequent paintings, squeeze out a generous portion of each of the three colours. You can use a palette such as this or even a white ceramic or enamel plate. If you are using a plate, squeeze the paint around the edge of the plate. For our first project you will need a strong purplish mix of cobalt blue with Winsor red as a basis for the sky, and a mix of cobalt blue and quinacridone gold for the shrubs.

2 Using the wash brush, thoroughly soak the upper two-thirds of the paper. When properly wet, the paper will have a distinct shine. If there is no shine or only a dull shine, add more water.

3 With the paper inclined at an angle of at least 20 degrees, apply some of the purple mix to the sky area using the round brush.

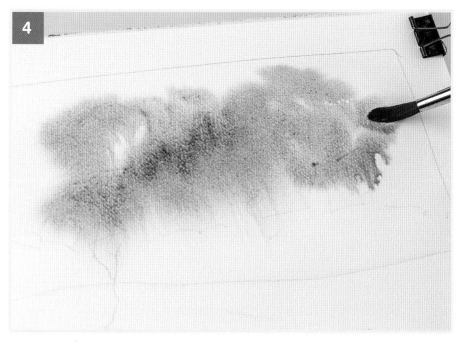

4 Immediately add a little cobalt blue into the sky. There is no need to rinse your brush – just dip straight into the cobalt blue and then drop it in (see Jargon Buster, below). The paper should still be wet enough to allow the cobalt blue to flow.

JARGON BUSTER

Dropping in is where wet paint is introduced to wet paper by just touching it to the paper. The water already there will allow the paint to flow.

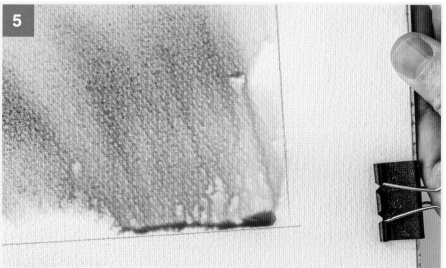

5 Tilt the paper left and right and up and down to create a wet-in-wet wash. Leave some white paper or allow the paint to cover everything except the front snowy area, as you prefer.

6 It is important to dry up any excess paint. If you don't, there is a risk that the paint may run down the paper or create runbacks or cauliflowers (see Jargon Buster, below). Use a paper towel or the tip of a just-damp brush to soak up the excess paint.

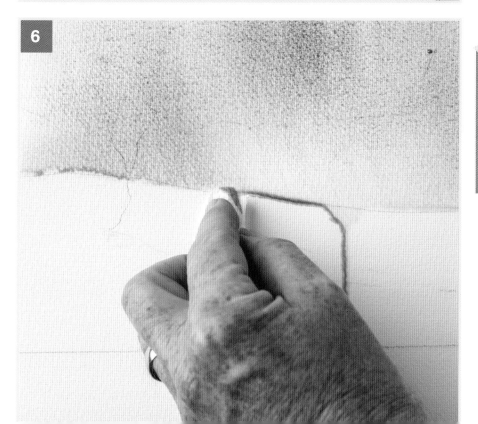

JARGON BUSTER

A runback is formed when an area of wet paint runs into an area that is almost dry. The resulting mark looks a little like a **cauliflower.**

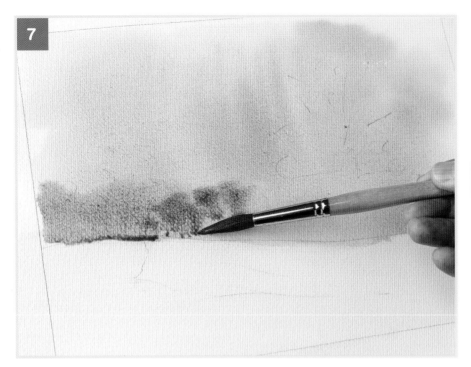

7 When the wet shine has just disappeared, paint some of the green mix into the lower part of the sky to create the illusion of distant shrubs. Add some of the pure cobalt blue and quinacridone gold to the green and mix gently on the paper to create variety.

Tip

When painting wet-in-wet, always add strong paint to weak. If you add weak to strong you will almost certainly end up with a cauliflower (see page 11).

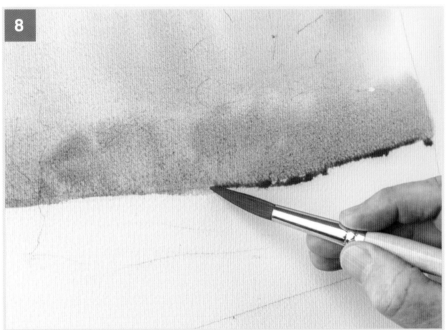

8 Continue the line of shrubs across the whole painting, adding in a range of different colours for variety. Again, it is important to dry up any excess paint at the bottom; a clean, barely damp brush will suck up any excess moisture.

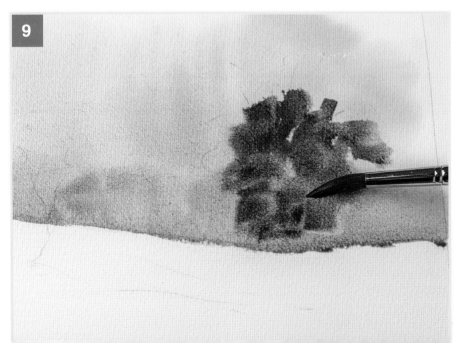

9 Using a slightly drier mix of the cobalt blue and Winsor red, brush in rough strokes using the side of the round brush, mimicking the shape and direction of the growth of a tree.

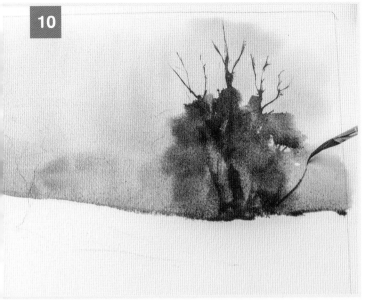

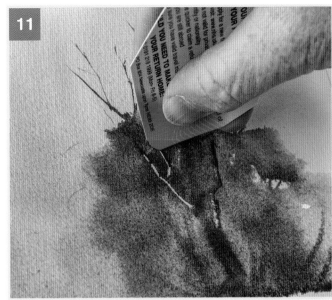

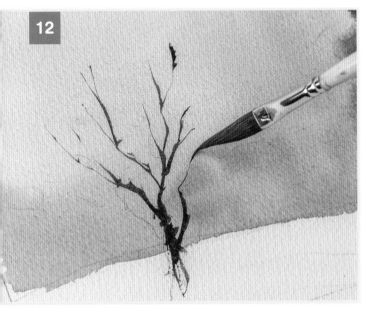

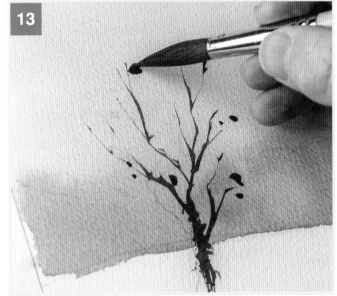

10 While the tree is still damp, use the swordliner to indicate some branches and twigs with the same mix. Hold the brush right at the end and let the tip dance over the paper. Practise with the swordliner first to achieve this free movement.

11 Using your nail or the corner of an old credit card, scrape out some lighter branches. If the tree is too wet the colour will flow back into the scraped-off area; in this case, wait 20 seconds and try again. If the tree is too dry, you won't be able to scrape out.

12 Use the swordliner to paint a little sapling on the left-hand side. This needs to be painted with quite a strong dark that is made by mixing all three colours together.

13 Finish the sapling with a few spots of an orange mix made from Winsor red and quinacridone gold, to suggest a few leaves left from autumn.

JARGON BUSTER

Scraping out is where the paint is physically scraped off the paper using your nails, a palette knife or, as shown here, the corner of a credit card.

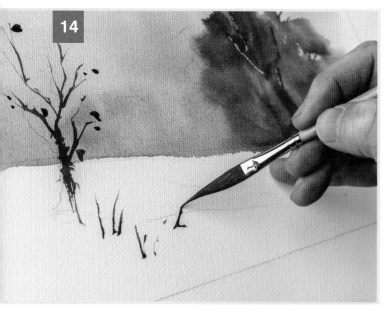

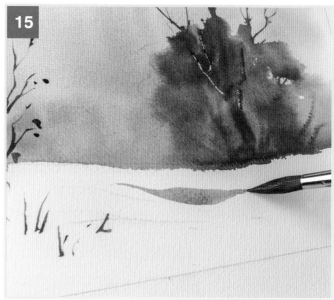

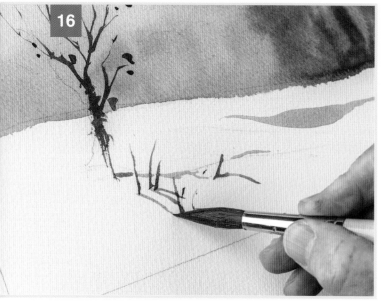

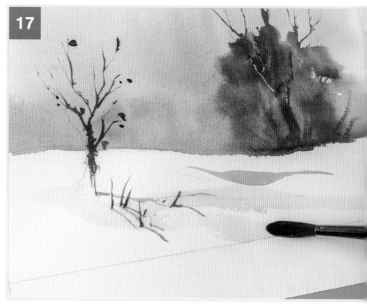

14 Back to the swordliner now: add some blades of grass peeping through the snow. For this, use your green, but vary the mix for some of the blades by adding a little Winsor red. If any of your greens are a little too bright, Winsor red will dull them.

15 Using pure cobalt blue mixed with water, use the round brush to paint a single stroke of snow shadow. Start by touching the paper with just the tip of the brush, then gradually press a little harder for a wider stroke, finally lifting slowly to get the taper.

16 Use the same blue mix to paint the shadows of the sapling and grass.

17 Using a wash of quinacridone gold mixed with just a touch of Winsor red, create a little colour variety in the snow. Painting the strokes with a slight up and down movement helps to describe the undulating snow.

Tip

For this painting, most of the snow is left as untouched paper. While this does work, it is not the only effective method for describing snow. We will use more colour in the snow in some of the later paintings; the snow only has to be light – not necessarily white.

Your first finished painting! In the next project you will develop this simple landscape by using more varied colour painted wet-on-dry.

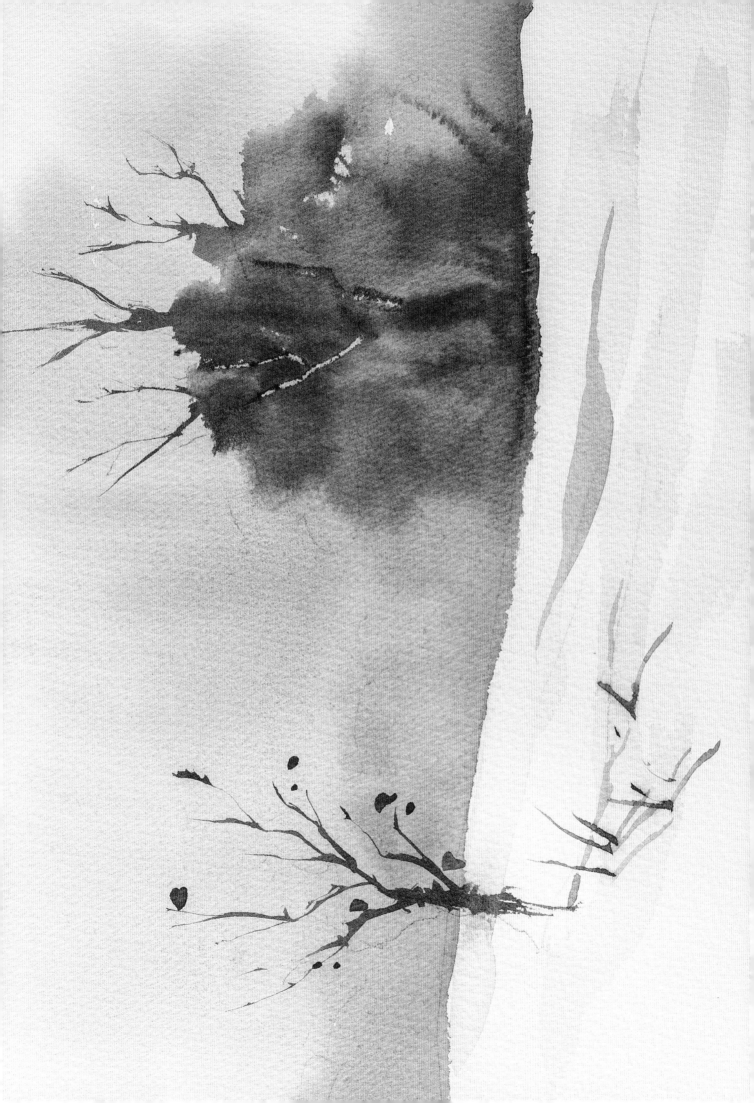

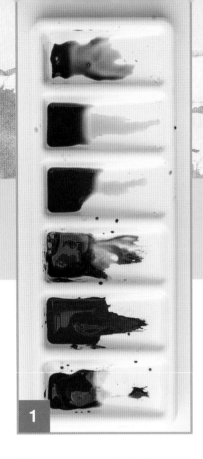

Snowy Hills

What you learn:

- **Painting distant and close hedgerows**
- **Using your finger to blur wet paint**
- **Creating sparkle with strong darks**

Tip

You may think that if you painted a little drier you wouldn't have all this excess paint to dry up... NO! The drips of excess paint are proof that you are painting wet enough to allow the paint to flow.

Tip

Always clean out your mixing areas before beginning a new painting and also top up your pure paint. Always squeeze out at least an amount that would cover your thumbnail.

1 Use the finished painting on page 19 and the tracing guide on page 64 to transfer the outline to your paper. Secure the paper to your board. We will use more varied colour this time but we will start with a cool green mixed with cobalt blue and just a little quinacridone gold. Also prepare a purple mix of cobalt blue and Winsor red, as well as a weak orange-brown mixed from Winsor red and quinacridone gold with a touch of cobalt blue.

JARGON BUSTER

A flat wash is a wash using a single colour and tone of paint. The intention is to paint an area of paint that varies as little as possible.

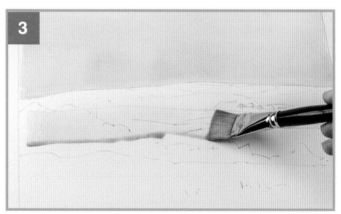

2 After pre-wetting the angled paper, paint a flat wash of cobalt blue from the top of the paper to the edge of the distant hill using the wash brush. Dry up any excess paint (see step 6, page 11) and allow to dry.

3 Paint a single stroke of water along the top of the hill using the wash brush. Immediately follow this with a wash of cobalt blue painted into the lower edge of the water stroke. Stop at the snow line, dry up the excess paint and allow to dry.

4 Paint a flat wash of the orange-brown mix onto the foreground snow using the wash brush. This should be strong enough to give a nice warmth to the area but not so strong that it turns the snow orange.

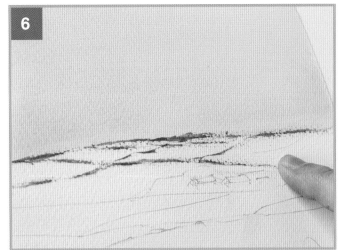

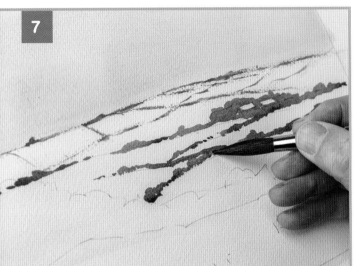

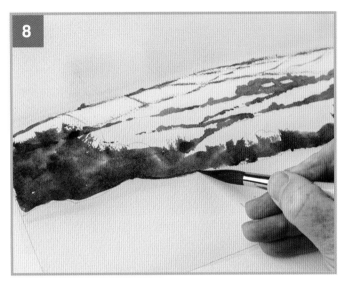

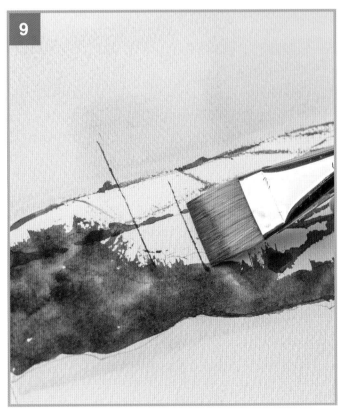

5 Now for the hill. Using a strong mix of cobalt blue with just a touch of Winsor red, apply a broken line with your round brush for the distant hedgerows. While this is still wet, use your finger to blur the line a little. The blurred mark helps to convey the sense of distance.

6 Using the same method, continue down the hill. Use the direction of the hedges to help describe the hill. The right-hand hedges are more angled towards the right.

7 Continue the same process but vary the colour more as you approach the foreground and make the lines generally thicker and darker. Drop colour into the wet lines. The actual colour is not really important; it is the variety that is key.

8 Paint the closest hedgerow with your cool green mix and the round brush but, again, drop in other colours as you go. Adjust the bottom edge to give a smooth undulation to suggest the tops of the snow banks beneath. Although you are painting the bottom edge, you are effectively painting the top of the snow.

9 Using the edge of the flat brush, introduce a couple of telegraph poles. Use a grey mixed from all three paints.

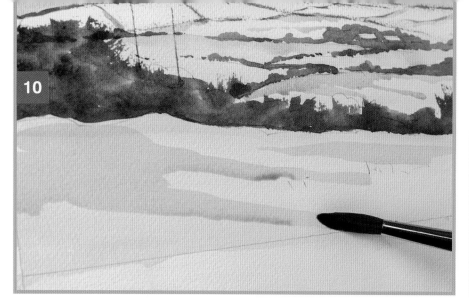

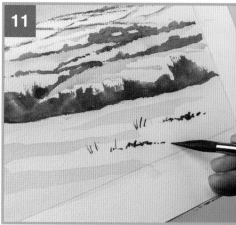

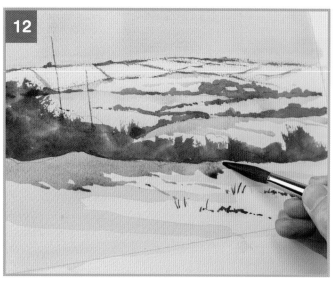

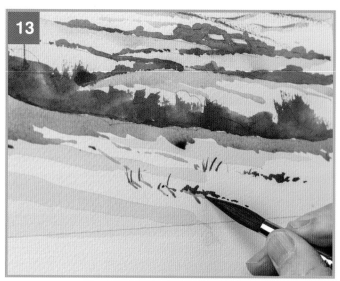

10 Mix a pure cobalt blue wash and apply a suggestion of shadow on the distant snow-covered hills with the round brush. Using a slightly stronger orange-brown mix than the one used in step 4, apply a partial wash to the foreground snow. Again, we need to introduce variety, especially to the foreground.

11 Using an even stronger orange-brown mix, paint a few areas of dried grass.

12 Introduce a foreground shadow using a mix of pure cobalt blue and water. Allow the brushstrokes to describe the undulations in the snow.

13 Continue using the cobalt blue mix to indicate the shadows of the grass.

14 Mix a strong dark using all three colours and apply this in touches over the closer hedges. These touches of strong darks suggest the strongest shadows, but more importantly, they create a sparkle with the strong contrast against the light areas. Use the side of the round brush to create drybrush shadows and touches in the closest hedgerow – refer to the finished painting, opposite.

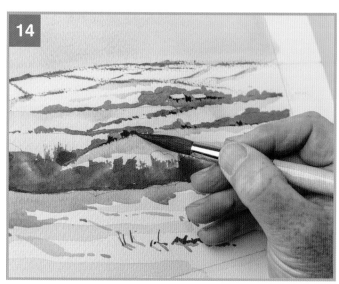

The finished painting. In the next painting you will combine the techniques from the first two to create a more complex landscape.

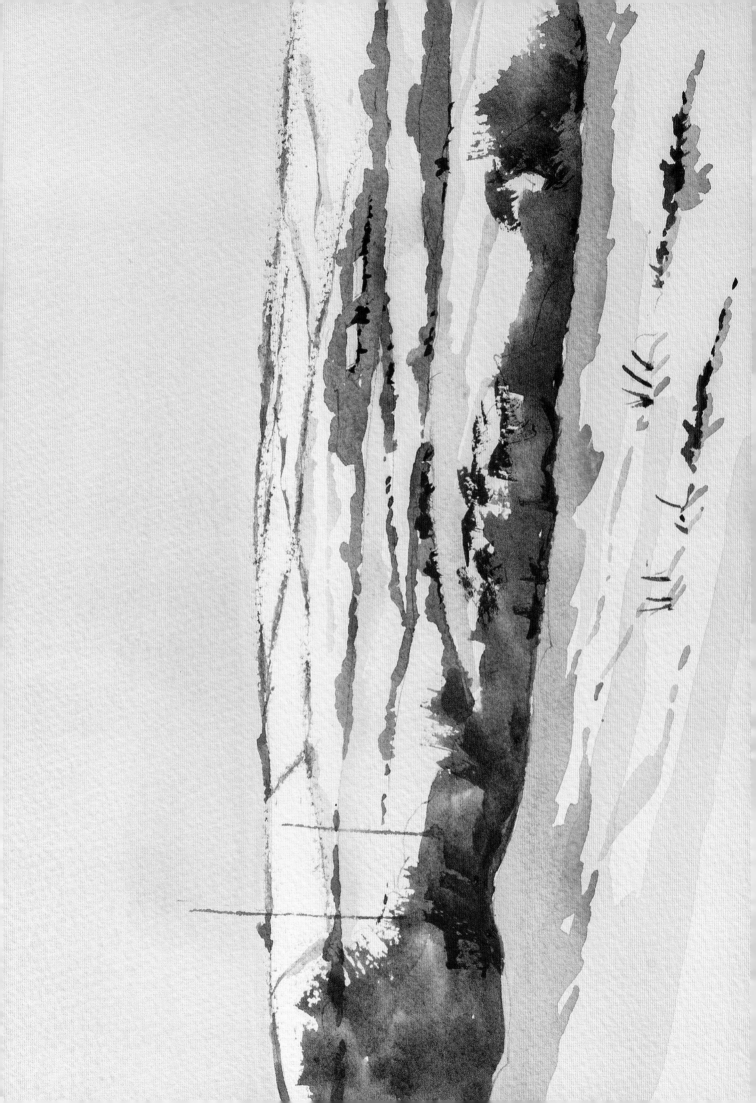

Snowy Road

What you learn:

- **Perspective**
- **Counterchanging lights and darks**

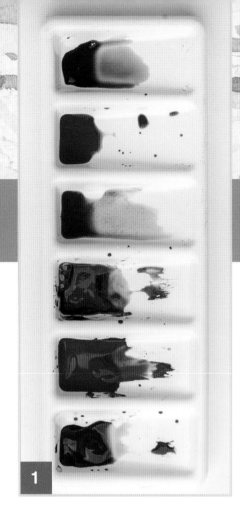

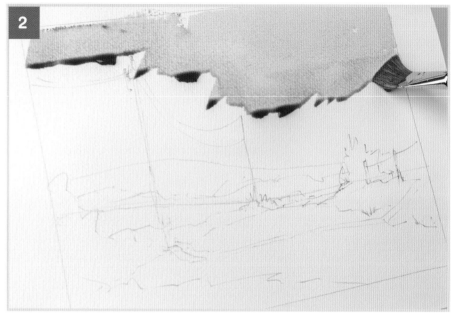

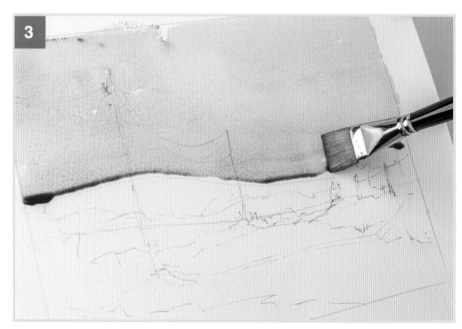

1 Use the finished painting on page 25 and the tracing guide on page 64 to transfer the outline to your paper. Secure your paper to your board. A lot of the colour mixes for snow are quite similar but you will be surprised at how much you can vary them by slightly altering the proportions. Mix up a purple with cobalt blue and Winsor red, a green using cobalt blue and quinacridone gold and a warm mix from Winsor red and quinacridone gold.

2 Use a wash of cobalt blue along with a little of your purple to paint a varied sky on your angled paper. Allow the edges to blend on the paper. This is best done on dry paper, as you will be better able to control the blend; if you are having trouble, you can pre-wet the sky area – the blending will be smooth but more random.

3 Paint down to the top of the hill and finish with a clean edge. Dry up the drips with the tip of the round brush; leave to dry.

Tip

Mix each colour with plenty of water as you don't want to run out of wash halfway through. Any leftover wash can be used in another part of the painting.

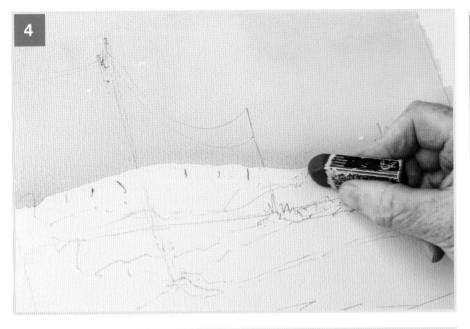

JARGON BUSTER

When you are painting the 'bottom' of the sky, you are really painting the top edge of the hill. This is called **negative painting.**

4 If you have an obvious pencil line at the top of the hill, erase it now. This will have the effect of making the edge less obvious and seemingly push it back.

5 Paint a pale wash of cobalt blue over the distant hill using the round brush and allow it to break up as it nears the hedge. While the blue is still wet, create the hedge with the green mix, using the side of the round brush. Ideally, you want the top edge of the hedge to soften into the cobalt blue on the hill in places, as well as being harder edged on dry paper in others. When all is dry, paint an undulating shadow on the near field using your round brush and a slightly stronger cobalt blue than you used on the hillside.

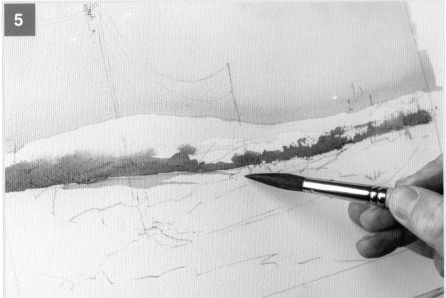

6 Paint the closer shrubs freely using the round brush and various greens and purples. Allow the green and purple to combine in places to give the closer shrubs more variation, as you would expect to see. Don't be afraid to experiment with colour mixing on the paper. These three colours are quite forgiving and you should find some lovely mixes. Use the swordliner to indicate a few twigs.

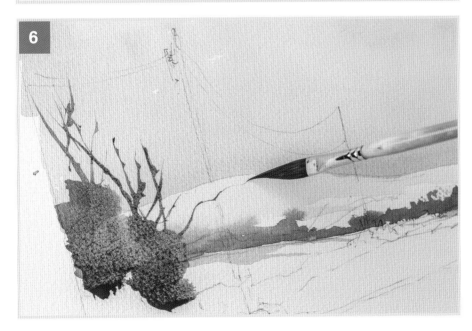

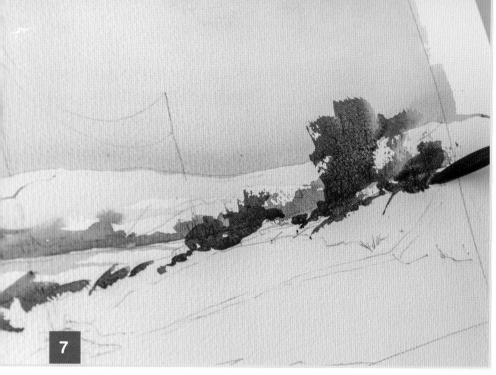

7 Continue to paint shrubs here and there below the telegraph poles towards the right-hand side of the painting. Don't try too hard to paint 'accurate' shrubs. It is more important that the shapes and proportions are reasonably correct. Use a variety of mixes and little angled strokes to suggest the angled bank at the side of the road.

8 While the closer hedge on the right is still wet, use some of the same colour mix to paint a fence. As long as your round brush has a good point, this shouldn't prove too difficult. Try to vary the fence posts – don't make them all perfectly regular and vertical.

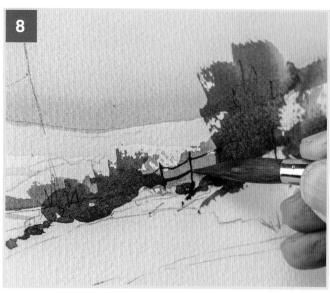

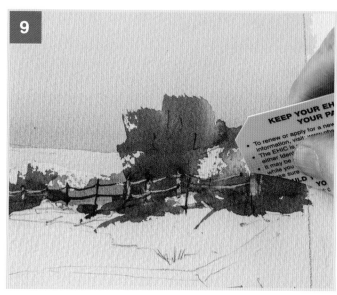

9 Using your nail or the corner of a card, scrape out the fence from the dark, damp shrub. This results in the fence being dark against a light background and light against a dark background.

JARGON BUSTER

Counterchange is where you have light and dark areas adjacent to each other – as with the fence.

10 Paint the telegraph poles using a medium-greyish mix of all three colours. I have used the edge of the swordliner, allowing it to fall gently down the paper. You could also use the tip of your round brush or the edge of your wash brush.

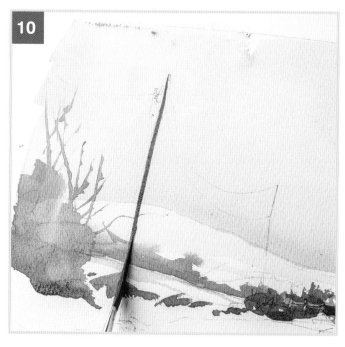

11 Continue to paint the other poles and lightly indicate the telegraph lines. It is actually better if you paint the lines so lightly that you miss sections. Our brains will fill these sections in.

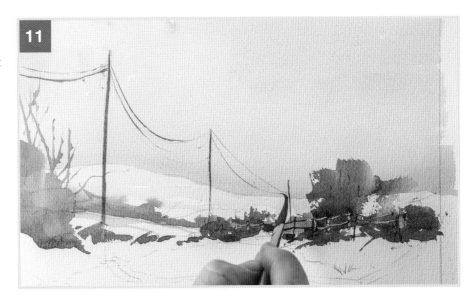

12 Using your round brush and the warm mix, roughly paint into the foreground area. This is to suggest the rougher lying snow in this area – the warm mix 'comes forward', helping to create the illusion of distance. This is part of what is known as aerial perspective.

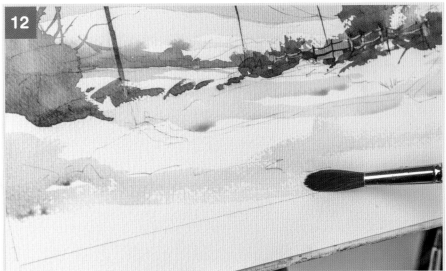

JARGON BUSTER

Aerial perspective is a method of creating an illusion of depth in a painting with colour. Paint distant areas bluer and paler; foreground areas should be warmer, stronger and with more contrast.

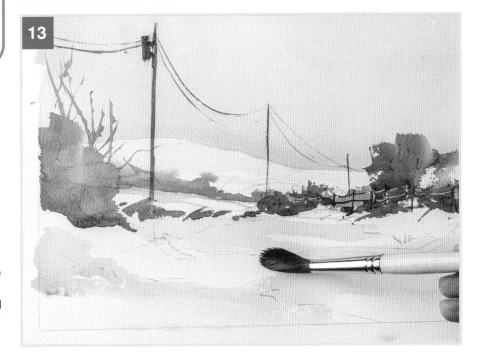

13 While the wash is wet, soften some of the foreground edges using a barely damp round brush – this will link the warm tones with the cooler white of the paper.

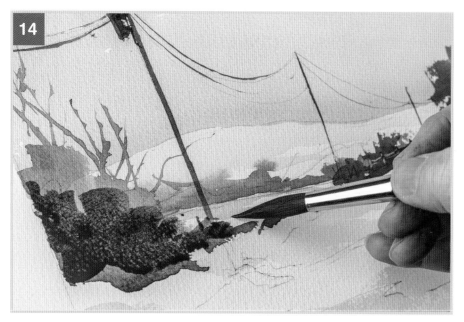

14 Strengthen up some of the closer hedge areas with a second wash, slightly stronger than your first, using the round brush.

15 Using your green mix, paint a few tufts of grass at the sides of the road. Don't paint a continuous line. Breaks in the line will make it appear more realistic. Also suggest the grassy ruts on the road. Start in the distance, gradually making the marks wider as you paint down the paper. The two lines of ruts should appear to converge as they recede but they should not actually meet. This is known as linear perspective.

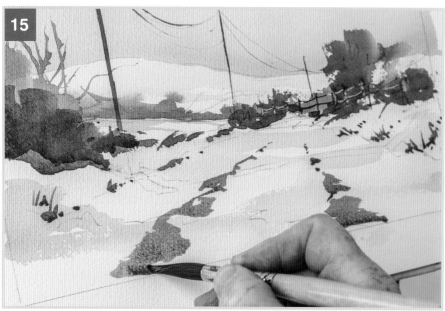

JARGON BUSTER

Linear perspective is the effect of objects appearing to change as they recede. Poles get shorter, tufts of grass get smaller and the road gets narrower. Also, details disappear.

16 Finally, paint a few closer shadows using a weak cobalt blue wash. Allow them to run down the bank and across the road.

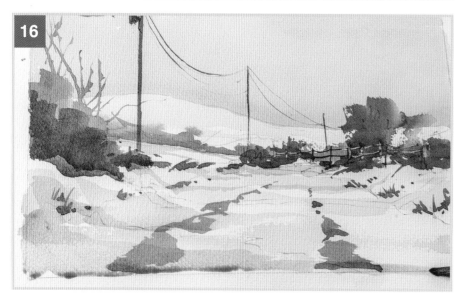

Tip

The direction of your brushstrokes should describe the surface. Paint vertical objects with vertical strokes, horizontal objects with horizontal strokes and diagonal objects with diagonal strokes.

The finished painting.
In the next painting we get a
little closer to trees and snow
banks and try to show their
three-dimensional shape.

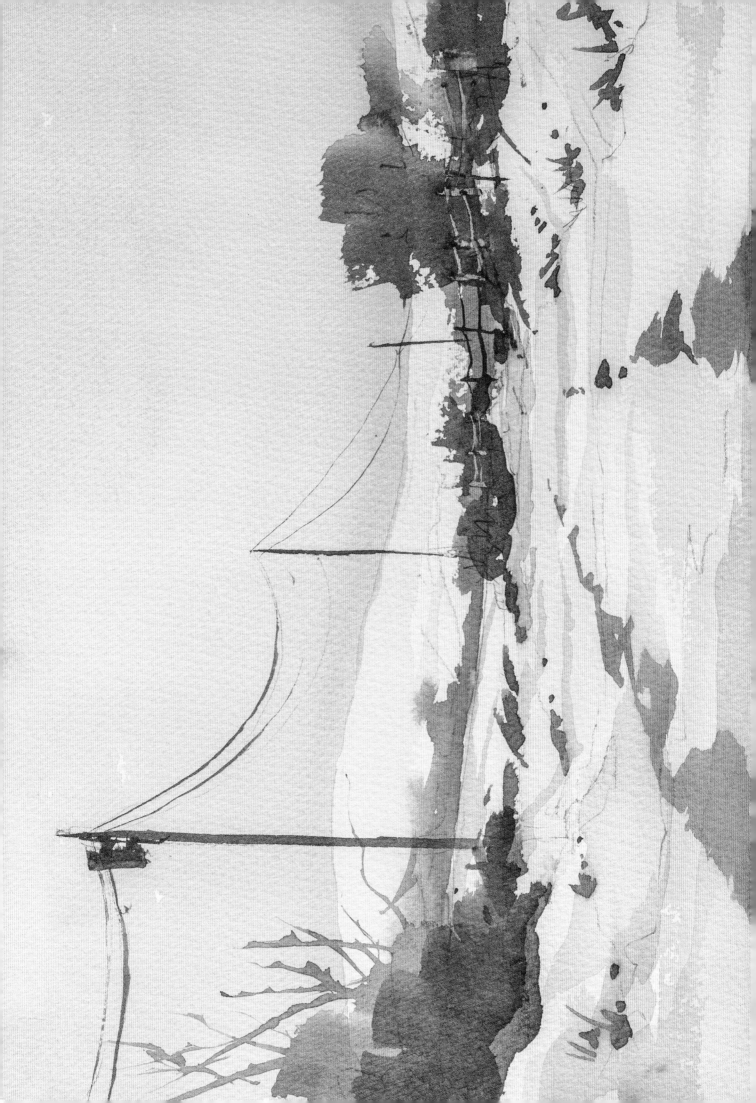

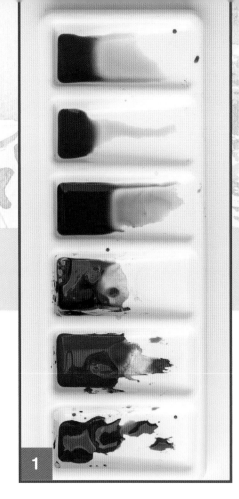

Streamside Tree

What you learn:

- **Lifting out**
- **Drybrush technique**

Tip

Always paint on an angled surface so that the paint flows down. Working flat will almost certainly result in the paint pooling, with very uncertain results.

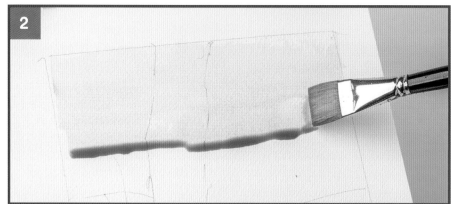

1 Use the finished painting on page 31 and the tracing guide on page 64 to transfer the outline to your paper. Secure your paper to your board. By now you should be confident with mixing colour. Mix green from quinacridone gold and cobalt blue, purple from Winsor red and cobalt blue, and warm orange from quinacridone gold and Winsor red.

2 We will first paint a wash from top to bottom without stopping and without leaving any white spaces. Start at the top using your wash brush and a weak wash of cobalt blue. Paint horizontal strokes, picking up the wet lower edge of the previous stroke. Get into the routine of dip, stroke, dip, stroke – your brush must always be well charged with paint.

3 When you have covered about one third of the paper, change to a weak purple but don't leave a gap between the blue and purple. Likewise, two-thirds down, change to a wash of quinacridone gold with just a touch of Winsor red. Ideally, you should finish with a wash that varies subtly in colour and has no white spaces or brush marks visible. Allow to dry.

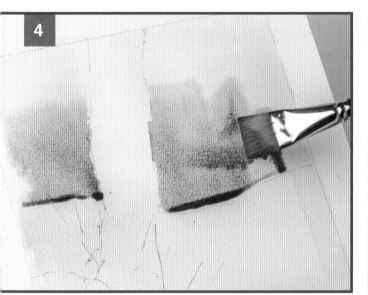

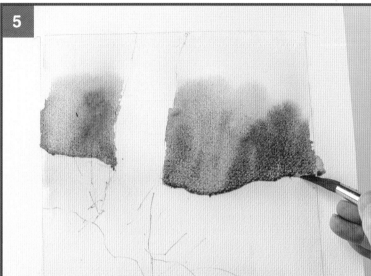

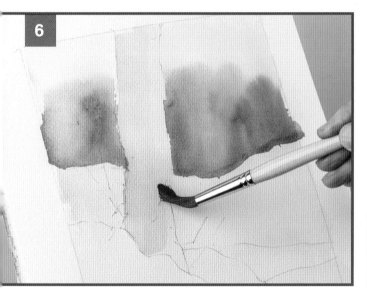

4 Re-wet the top of your paper, behind the snow bank, using clean water and your wash brush. Paint into the lower edge of the wetted area using the wash brush with any mix of greens, purples and blues. Allow the different colours to touch and blend, but try to avoid the foreground tree trunk. Feel free to drop in additional colour, but ensure the dropped-in colour is stronger than what is already there.

5 This area will eventually appear like distant trees, but don't try to add any twigs or leaves. Finish this area with a gently undulating line to suggest the edge of the snowfield. Dry up any drips with the tip of your round brush.

6 Wash down the left-hand side of the tree trunk with a weak mix of quinacridone gold, then immediately soften the right-hand edge with your damp round brush.

7 Add a few varied shadows to the snowfield using cobalt blue. Remember to vary the pressure on your brush in order to vary the thickness of the line.

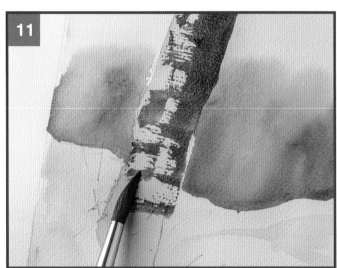

8 Mounds of snow will be lighter on top, graduating to a darker tone at the bottom. This can be indicated by first dampening the top of the mound to suggest the light.

9 While the top is still damp, introduce some cobalt blue wash into the bottom of the damp area and paint down to the top of the next mound. You should have a smooth tonal gradation, from light to slightly darker. Allow to dry and then continue with the remaining mounds.

10 Erase the pencil lines between the mounds; they will now look much more natural in appearance.

11 For almost all brushstrokes a brush full of paint is essential, but as the name suggests, the drybrush technique requires the opposite. With a purple (Winsor red and cobalt blue) or greyish purple mix (add a touch of quinacridone gold), dip your round brush in your mix but stroke it on the edge of the palette to remove as much paint as possible. Hold the brush pinched between index finger and thumb to give you good control, and make gentle horizontal strokes with the brush on the tree trunk from right to left. If your brushstroke gives a solid instead of a broken stroke, try first wiping it gently on a sponge or paper towel.

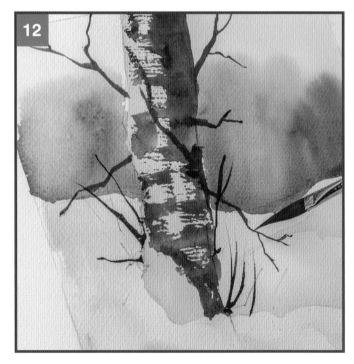

12 With a slightly stronger mix, paint a few twigs and tufts of dried grass with your swordliner. The dried grass can be painted using a quinacridone gold and Winsor red mix.

13 Use the same mix to paint a few leaves on the twigs using the round brush. Try to make each leaf very slightly different. Don't just dab the brush on the paper as this will tend to reproduce the same leaf shape.

14 Paint a few shadows with a cobalt blue wash and the round brush. Remember to paint in the direction of the lying snow, and as these are cast shadows they should have hard edges.

15 With the same wash, paint a few grass shadows using your swordliner. Again, take care to follow the contours of the snow.

16 On to the pool of water. Water will be recognizable as water mainly because of reflections. Reflections in general should be either slightly darker or lighter than the surrounding snow. Using a grey mix (all three colours) paint horizontal ripples with the round brush.

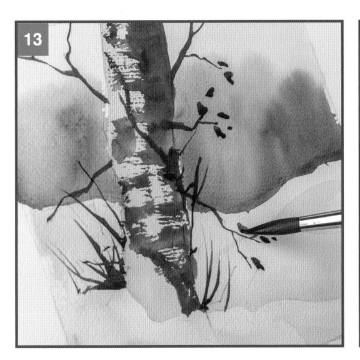

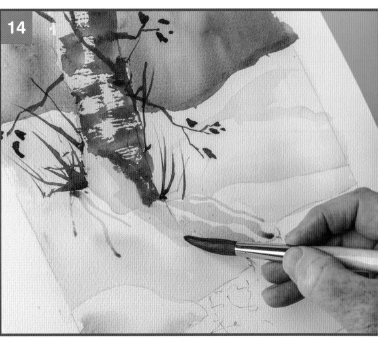

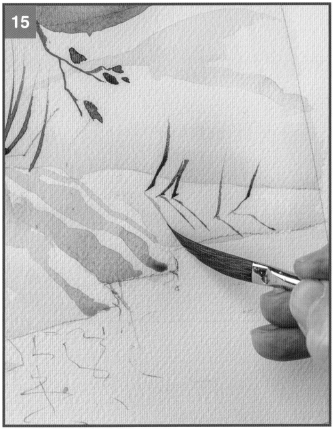

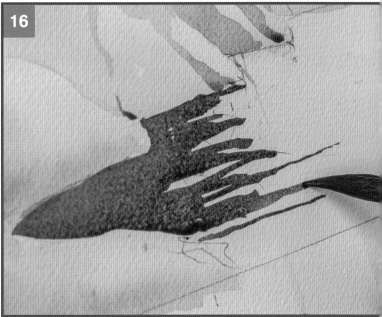

Tip

Make sure all of your shadows go in the same direction – they are all cast by the same light source: the weak winter sun.

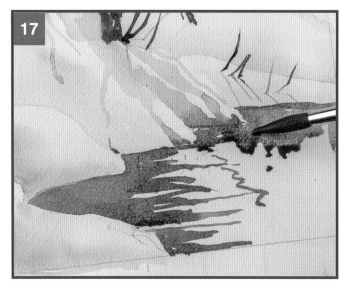

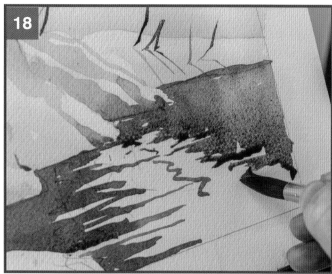

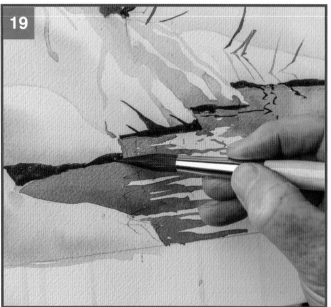

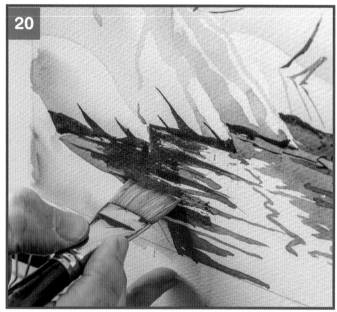

17 Continue along the boundary of the snow and water and introduce variety by painting in some other colours in vertical bands.

18 At the bottom of the vertical bands change to horizontal ripples. It is the vertical bands combined with the horizontal ripples that suggest the reflections.

19 Add a few darker accents with a stronger greyish mix; these darker areas appear mostly where the snow and water meet.

20 Continue to add in more of this dark mix in horizontal strokes in the water. Use the damp edge of your wash brush and a slight left-to-right scrubbing motion to lift out a few light horizontal ripples.

JARGON BUSTER

Lifting out refers to damp or dry paint being removed from the paper either by blotting with a tissue or with a slight scrubbing action of a damp brush.

Drybrush is a stroke made by a brush holding only a small amount of paint.

Here is the finished painting. We will stay with trees in the next project but introduce a variety of distant, medium-distant and close trees.

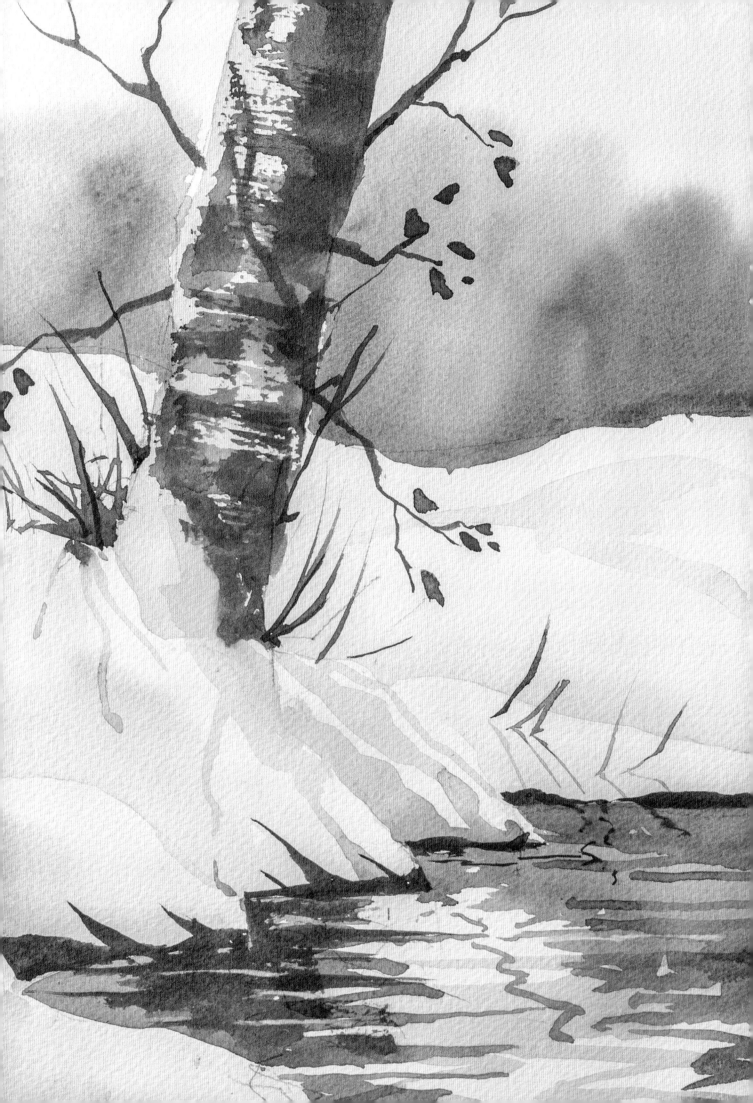

Winter Trees

What you learn:

- **The difference between background, middle ground and foreground**
- **How to create depth**
- **Different ways to paint trees**

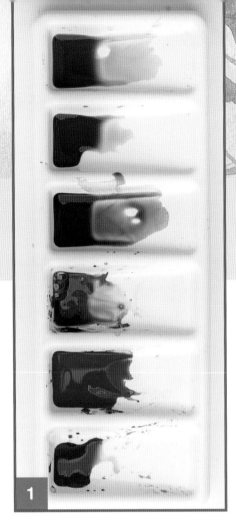

Tip

Winter skies are often better painted in a warm tone rather than blue, especially when approaching twilight. Colour is important but the tone or value of the colour is even more important. Take care to think of how light or dark you need the colour to be. Get into the habit of increasing strength by adding more colour, not by reducing the amount of water.

1 Use the finished painting on page 37 and the tracing guide on page 64 to transfer the outline to your paper. Secure your paper to your board. Start by creating a grey from all three paints, and a warm mix from quinacridone gold and Winsor red.

2 With the sun low in winter, the sky is often quite a warm colour. Start the wash with the grey and blend it with the warm mix. Using your wash brush, paint this down to the edge of the snow, then allow to dry.

3 Using the wash brush, roughly scrub in some diagonal strokes of the warm mix and immediately drop in some cobalt blue. Don't overmix the colours. The goal is to have some areas with warm colour, some with cool blue and some with a greyish colour that will result from a mix of the two. The diagonal strokes will help to suggest the slope of the hillside.

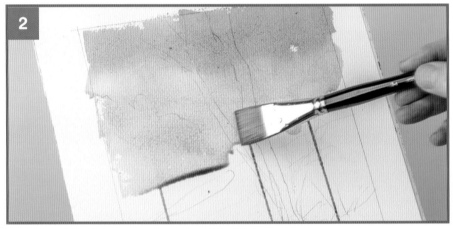

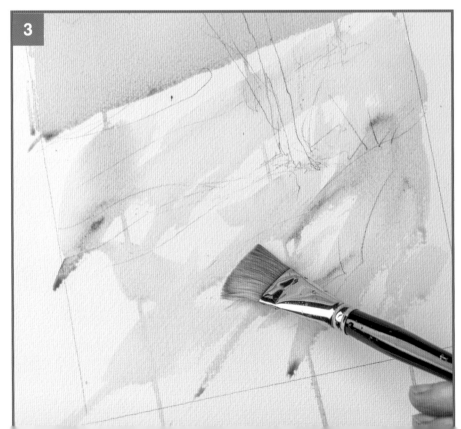

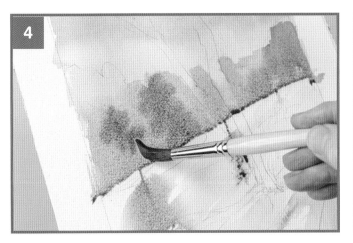

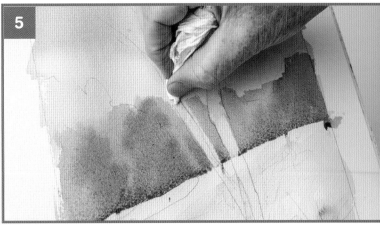

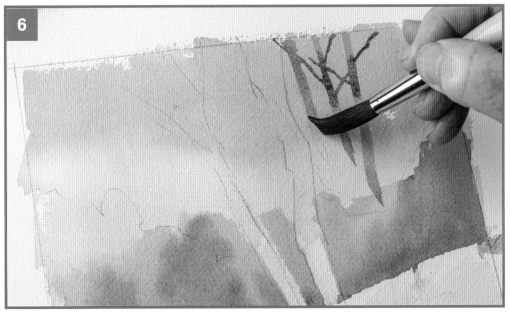

4 With the same colours but slightly stronger, paint a simple varied wash to suggest the background trees. Don't try to paint branches or leaves. The idea of creating depth depends on keeping the background simple – simpler than it would actually appear in reality.

5 Using a scrunched-up tissue, lift off the wet paint to leave a light space for the foreground trees.

6 Next we have the trees in the 'middle' of the subject. Here we must try to use a little more detail than in the background trees but not as much as we will use in the foreground trees. With the round brush, paint a simple silhouette of the group of trees using a soft purplish-grey (Winsor red plus cobalt blue with just a touch of quinacridone gold).

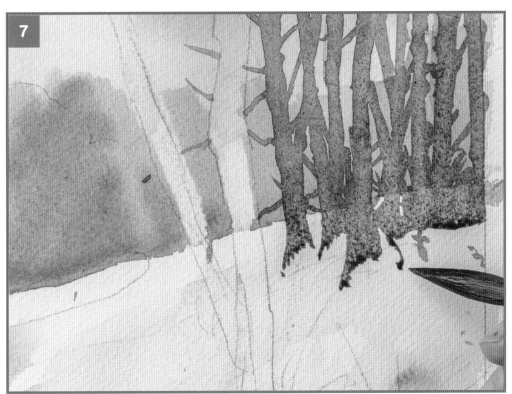

7 When painting these trees, try to make sure that they all blend seamlessly. Finish the bottom of the trees to suggest snow piling up against the trunks.

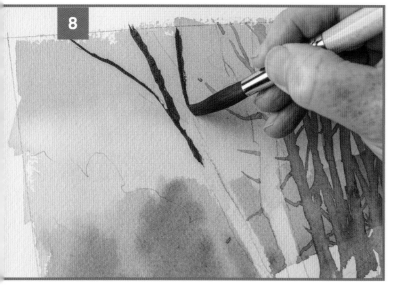

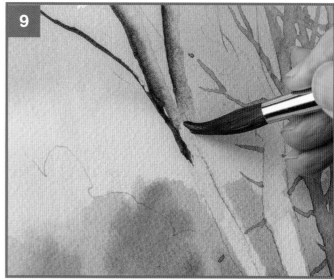

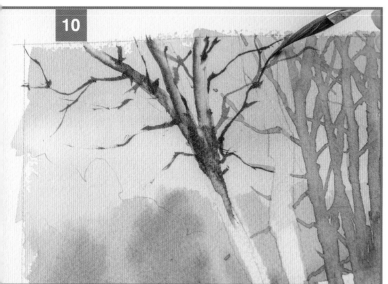

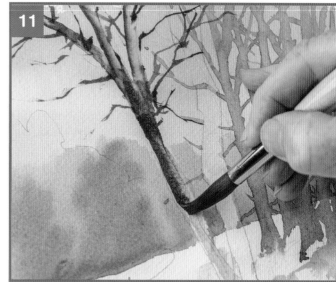

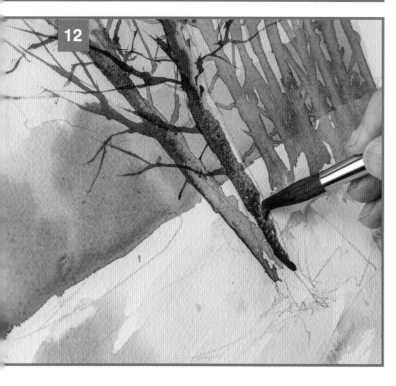

8 The foreground trees must have the greatest variety of colour and tone. Begin with a dark grey mix of all three colours and run this down the left-hand side of a few of the main branches with the round brush. It is important that the paint stays wet for the next stage so only paint as many as you can manage at one time.

9 Immediately run a wet brush down the right-hand side. If all goes well, the two tones will softly merge to give a good suggestion of the rounded shape of the trunk.

10 Switch to your swordliner and add a few smaller branches and twigs with the grey mix. Make some pass in front of the trunk of the other foreground tree and some behind. Also introduce a little quinacridone gold and Winsor red mix to warm up the trunk in places.

11 Continue down the trunk, repeating steps 8–10.

12 Paint the second foreground tree in exactly the same way. Try to create plenty of variation and allow some branches and twigs to cross the other tree.

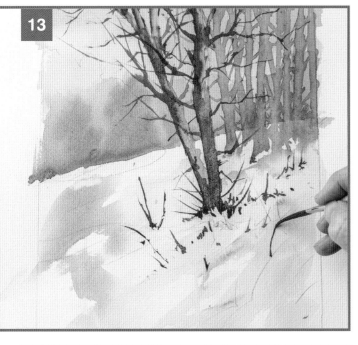

13 The fine tip of the swordliner is perfect for little twigs and grasses. For the grasses use quick, slightly curved strokes, and again use different colours and tones to create variety.

14 As with the previous project, use the round brush to paint drybrush for the bark (see steps 11–12 on page 28). This time, paint left to right – from the dark side to the light.

15 Introduce some more definite hard-edged shadows using cobalt blue and the round brush. Remember, you have the power to indicate the shape of the fallen snow with the shape of the brushstrokes.

16 Use gently curving brushstrokes and cobalt blue to create the gentle undulations of the snow. Snow will always form gentle curves, even when settling on sharply angled surfaces.

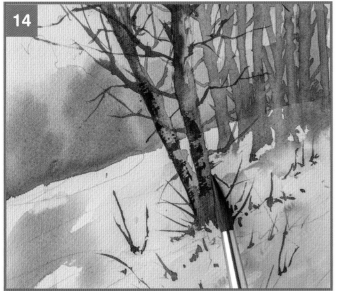

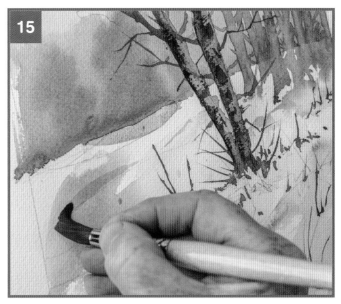

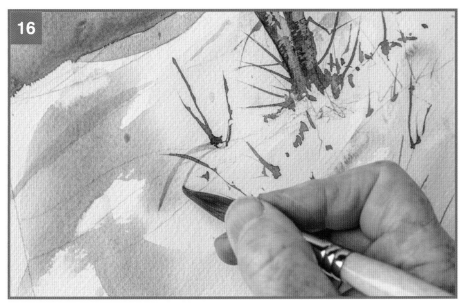

17 Paint a stronger shadow for both the foreground and middle ground trees. Allow the shadow to almost disappear in places – this is an effect of the uneven snow.

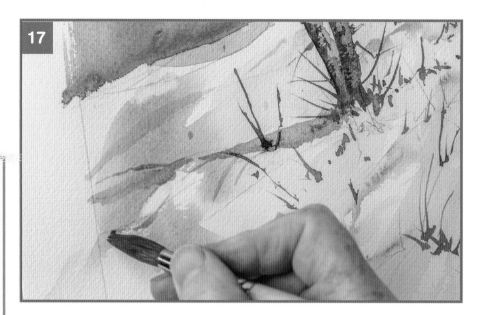

JARGON BUSTER

Different names are often used by different manufacturers for what is essentially the same pigment. Winsor Red, Permanent Red Deep, Lukas Red, Sennelier Red, Jackson's Red and Pyrrole Red are different manufacturers' names for paint all made from the pigment PR254. Conversely, and somewhat irritatingly, different manufacturers often use the same names for quite different pigments.

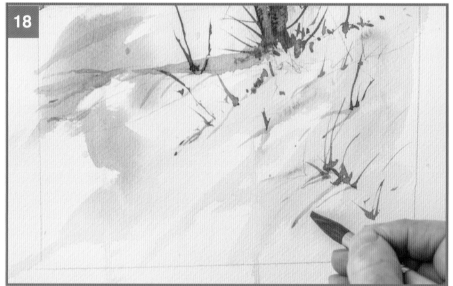

18 Continue to add shadow detail, where you feel it is needed.

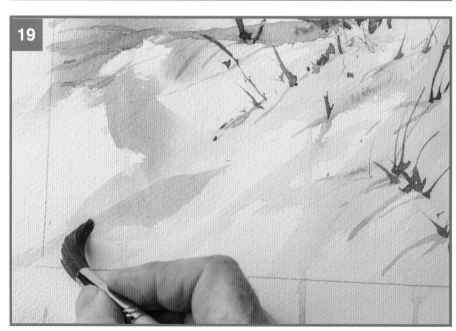

19 Add further shadow colour to 'shape' the snow drift.

The finished painting is shown opposite. For the next three paintings we will use the techniques practised in the earlier projects to create some more complex subjects; we will begin with a snowy sunset.

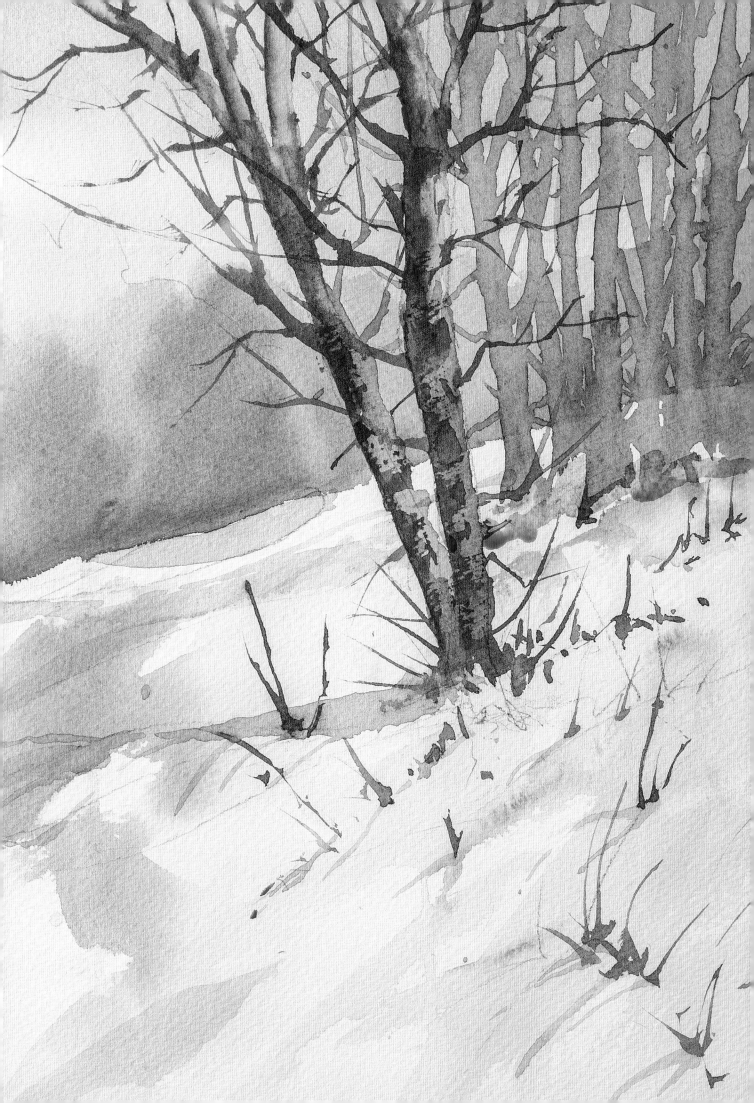

Snowy Sunset

What you learn:

- **Sunset colour**
- **How to create smoke**

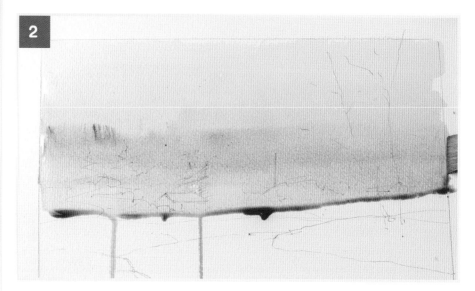

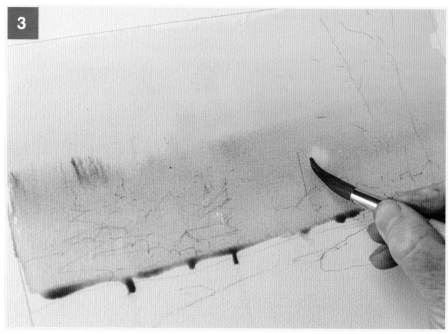

1 Use the finished painting on page 45 and the tracing guide on page 64 to transfer the outline to your paper. Secure your paper to your board. Sunsets contain predominantly warm colours. Sometimes the warm/cool descriptions can cause some confusion. After all, surely blue is a cool colour and yet you will read about warm and cool blues. Look at how the colour is biased. A blue that is biased towards red would be considered warm (such as French ultramarine) but a blue that is biased towards green would be cool (such as cerulean blue).

2 Starting with a wash of quinacridone gold plus a touch of Winsor red, start at the top of the paper and paint approximately half of the sky area. Add a little more Winsor red to the mix in the palette, then continue down to the edge of the snow-covered field.

3 While the sky wash is still quite damp, use the barely damp round brush to remove a little circle of paint to represent the weak winter sun. Make sure your brush is not actually wet – if it is, you will introduce water to the sky and probably cause a runback (see Jargon Buster, page 11). Dry up the excess paint along the bottom edge.

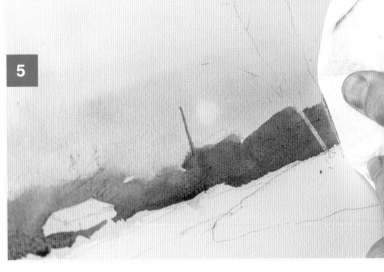

4 Now add a little cobalt blue to your sky mix to create a dull but stronger green-brown. Paint this into the lower part of the damp sky wash to create a soft-edged suggestion of distant trees. Use your round brush and vary the colour as you proceed. Exclude the little cottage but add in a telegraph pole with the same mix.

Tip

To make light, straight lines in a dark area of painting, fold a tissue around the edge of a credit card and use this to press and lift out the line from damp paint.

5 Using a tissue folded around the edge of a credit card, lift off lines of the wet paint to leave a light space for the two foreground trees.

6 When the sky is dry but the background trees are still wet (timing is everything!), paint in the conifers using a warm greyish-green mixed from all three colours. This mix must be stronger than the damp mix that is already there. Paint the conifers with the tip of your round brush, holding it away from the ferrule, using a side-to-side motion.

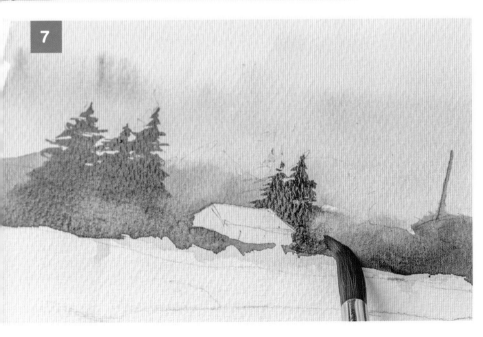

7 Paint a couple of additional conifers behind and to the side of the cottage. This will give a stronger contrast against the snow-covered roof, making the snow appear lighter.

JARGON BUSTER

The **ferrule** is the part of the brush that connects the hair to the wooden handle. It is usually made of metal, but brushes known as mops often have a plastic ferrule wrapped with wire. In days gone by, it was made from quill.

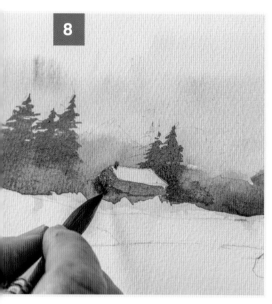

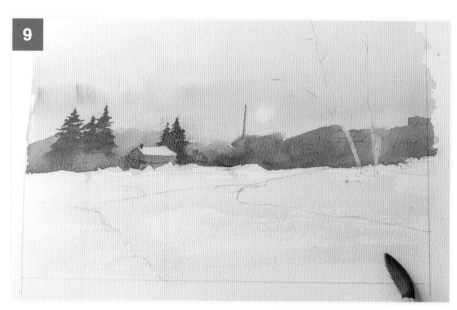

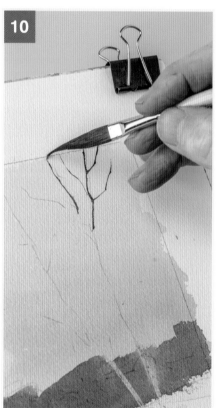

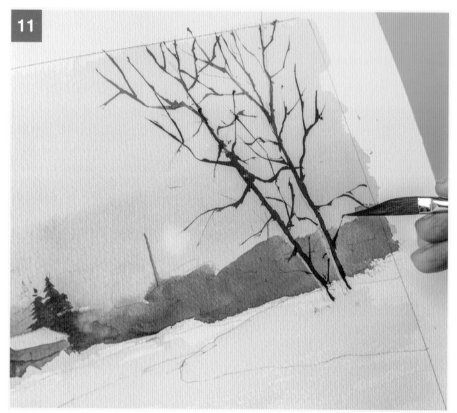

8 Add a little water to your conifer mix and paint the walls and chimney of the cottage.

9 With the original sky mix, introduce some warmth into the foreground snow. Make the marks fairly random, but still paint your strokes in the direction of the underlying snow and water.

10 Change to your swordliner and start to paint the trees using the conifer mix. Begin at the top of the tree and work down. It may appear that painting from the bottom up would be more logical, but this results in your paint flooding down and probably causing a run.

11 Adjust the colour as you work down the trees, but try to leave a sliver of light on the left-hand side. Tree trunks have quite a range of colour, even though we may think of them as plain grey or brown.

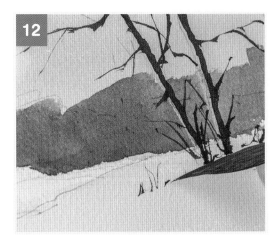

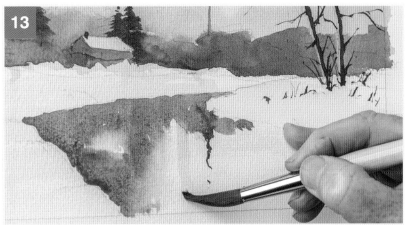

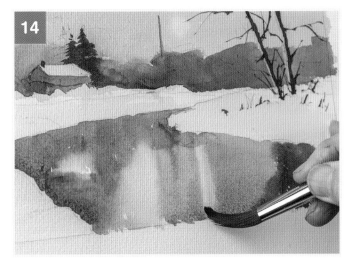

12 At the bottom and around the trees, paint a few blades of grass using the same mix.

13 Paint some reflections into the river using mostly vertical strokes. Try to achieve softly blending bands of colour, but vary the tone to reflect the tones above the river. Use a variety of greens, blues and browns.

14 Use your damp round brush to lift out a vertical band in the water underneath the sun.

15 Introduce some shadows using a cobalt blue wash and the round brush. Keep the top of the shadow soft-edged but allow the bottom to be hard-edged, as in the Streamside Tree project (see pages 26–31).

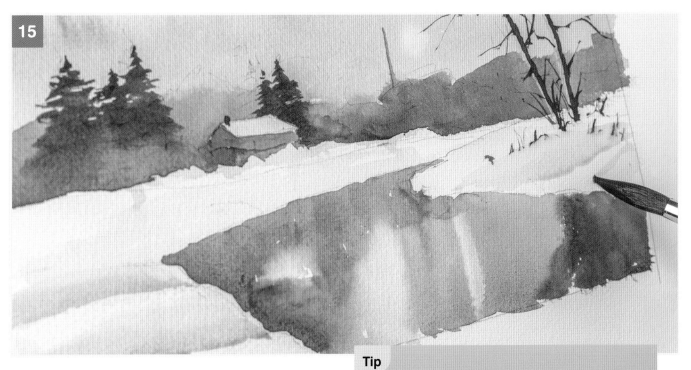

Tip

Reflections are almost always longer than the object that is being reflected. This is because ripples on the water act like curved mirrors, greatly extending the reflection.

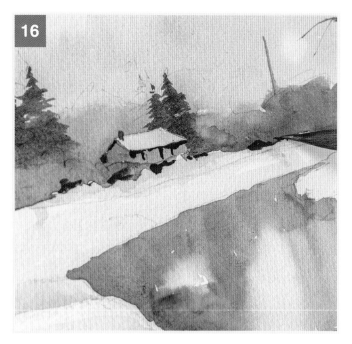

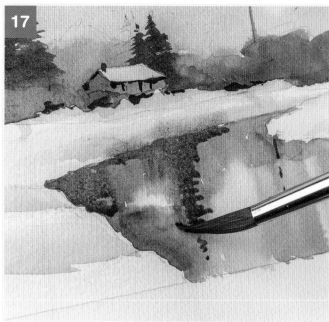

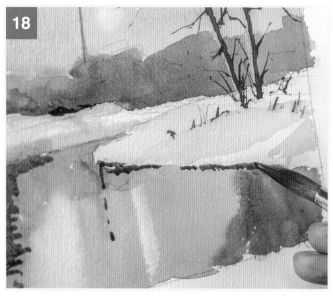

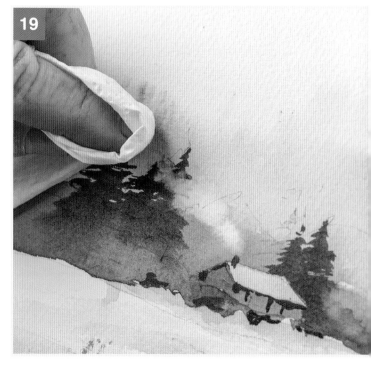

16 Use a stronger mix of the three colours to suggest subtle details on and around the cottage.

17 Dilute the mix a little, then add a few more definite reflections, concentrating on horizontal strokes to suggest the ripples.

18 Apply a broken edge along the riverbank. As well as suggesting the melted snow, the dark paint creates a stronger contrast, again making the snow appear lighter.

19 Wet the area above the chimney with water and your round brush. Leave for 20–30 seconds, then gently blot off some colour to suggest smoke. If the paint is reluctant to lift, scrub the paper lightly with your brush.

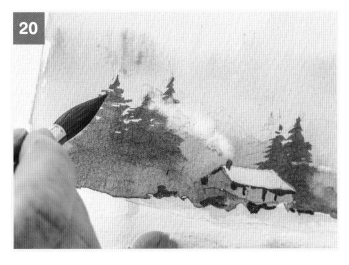

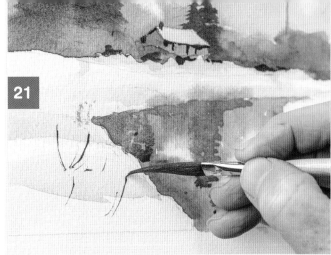

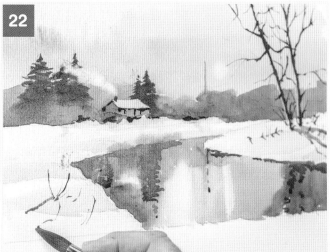

20 When the light of the sky is behind the smoke, the smoke will appear to be darker than the sky. Introduce a little weak cobalt blue to mimic this.

21 Add a few longer grasses to the left-hand foreground using a mid-brown mix and your swordliner.

22 Create cast shadows from the grasses. When the sun is in front of you, cast shadows will point away from the sun. This is one occasion when shadows are cast in different directions. When the sun is to the side, the angles are all the same.

23 Add a few stronger marks to the far river bank, where it meets the water. Then add in some further soft orange tones to the water, to reflect the sky colour (refer to the finished painting). The painting can be considered finished at this point, but the sky is lacking a little interest to my eye, so for the brave, or perhaps foolhardy, on we go.

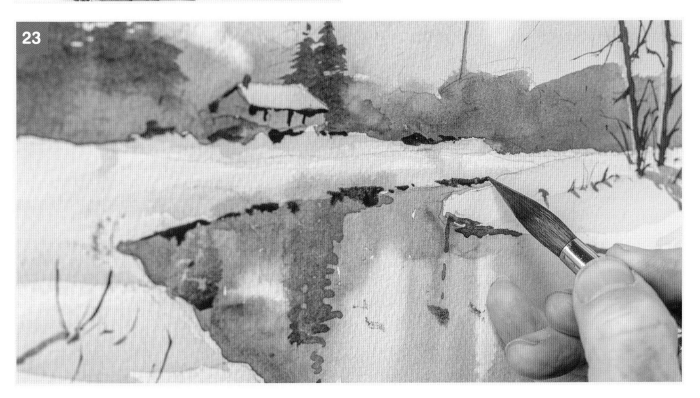

43

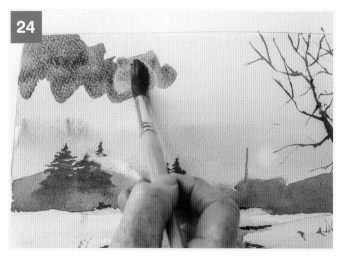

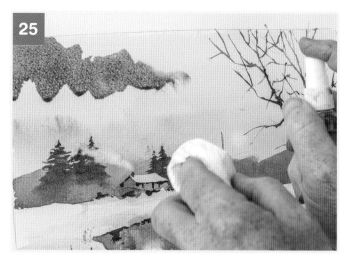

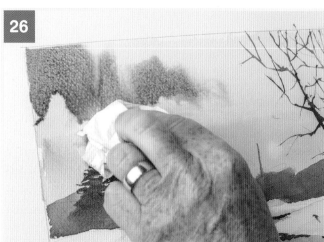

24 Using a purplish mix of cobalt blue and Winsor red with a touch of quinacridone gold to grey it slightly, quickly paint in the rough shape of a cloud.

25 Immediately spray the cloud area with water, but be ready with a tissue in your other hand to prevent the excess water from running down the paper.

26 Use the tissue to dry the edge. This will produce the effect of a light cloud in front of a dark one.

27 As the dark cloud dries, paint will continue to run down to the edge. Lift these drips with the tip of your damp round brush so that runbacks don't form.

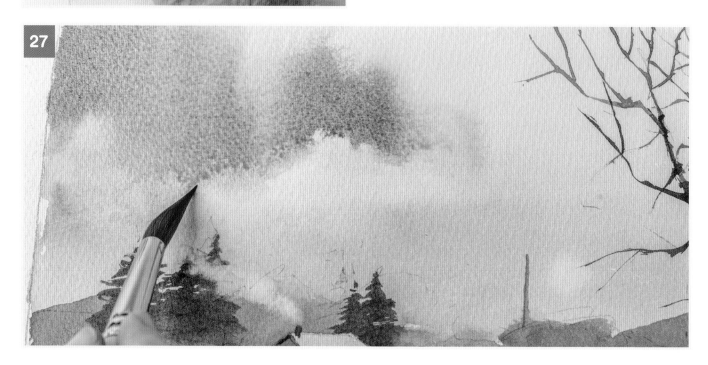

The finished painting. There is quite a lot to do in this painting, so don't worry if you don't get it right first time. It is worth practising the different techniques on scrap paper to gain confidence. Next, we will paint a snowy mountain scene.

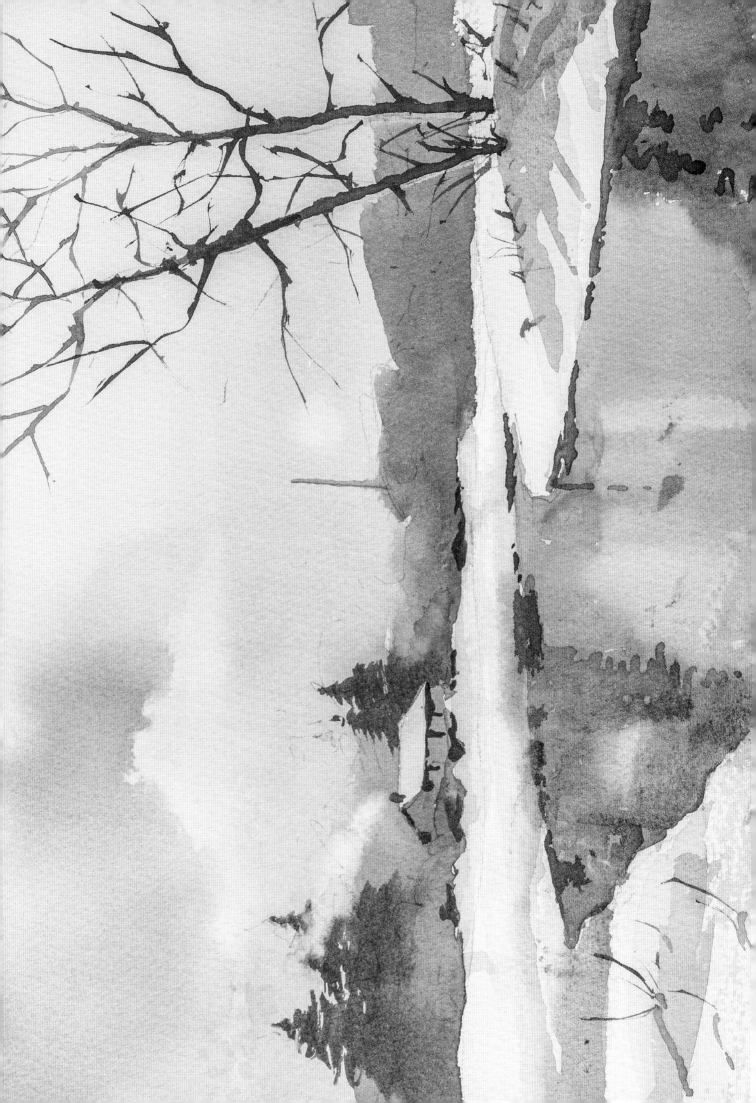

Snowy Mountains

What you learn:

- **Creating the illusion of distance**
- **Adding interest with a figure**

1 Use the finished painting on page 51 and the tracing guide on page 64 to transfer the outline to your paper. Secure your paper to your board. In mountain areas, the colours are likely to be predominantly cool, with warm colours providing small contrast and accents.

2 Begin with a wash of cobalt blue to indicate the blue of the sky. Use the round brush, as we are painting areas smaller than for some of the other paintings.

3 To introduce some cumulus clouds, continue the sky wash with clean water. Don't leave any dry gaps.

4 While the sky is still wet, quickly blot out the edge of each cloud with a scrunched-up paper towel.

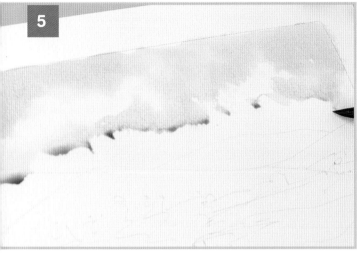

5 Introduce a little blue-purple mix, mostly cobalt blue but with a touch of Winsor red. This is to give a hint of cloud shadows and add natural variety.

6 Continue the sky wash down to the edge of the two near mountains. Blot out a few additional clouds with the tissue.

7 Using a slightly darker version of the blue-purple mix, paint in the distant third mountain, but leave patches of the sky colour showing through. The untouched areas will read as sunlit snow and the painted areas as shade, but because the main forward mountains remain as unpainted white paper, the distant mountain will appear to be much further away.

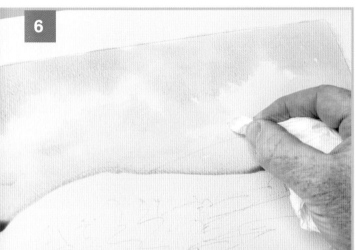

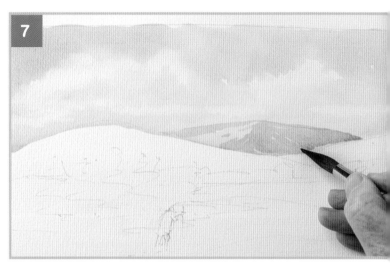

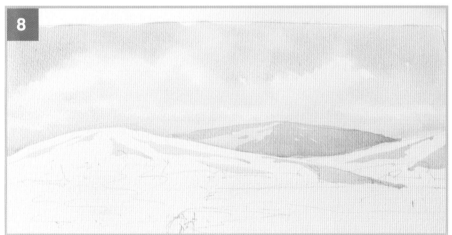

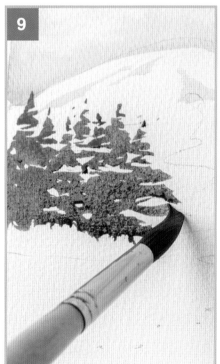

8 Using the same mix, paint in some shadow areas on the closer mountains. Pay attention to the direction of your strokes as this will help to suggest the shape of the mountains. Your strokes should essentially point to the summit of each mountain (but don't make it too obvious).

9 Paint in the conifers using a mix of quinacridone gold and cobalt blue with a side-to-side motion. As in the last painting, think of the shape and structure of each tree but allow each one to blend with the next. We are looking for a group of trees, not a number of separate individuals.

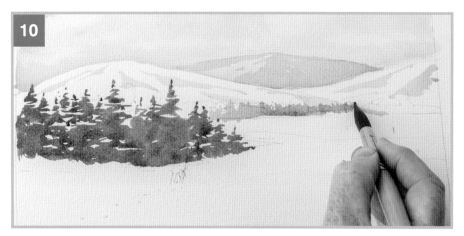

10 Paint the distant conifers in a similar but simpler way, using a paler mix of cobalt blue with a touch of quinacridone gold.

11 To start the figure, lift out the part of the figure that overlaps the trees. Take your round brush, slightly damp, and use a gentle scrubbing action to remove the paint.

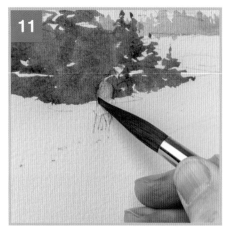

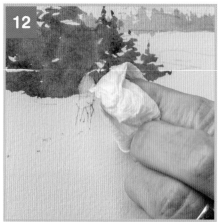

12 Press on the area with a tissue to lift off the colour. You may think it would have been simpler to paint around the figure, but this would have made the tree wash more stilted and made the figure too hard-edged.

13 Paint the coat on the figure using pure Winsor red with just enough water to avoid a sticky feel to the paint.

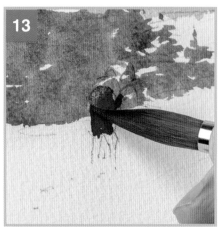

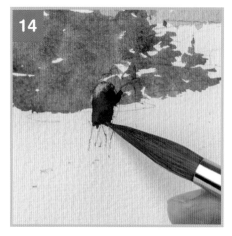

14 Immediately blot out a little light on the left shoulder and follow this with some shadow on the right of the coat. For the shadow, just add a touch of cobalt blue to the red used for the coat.

15 With that same dark mix, add the head and legs. It might appear logical to begin with the head, but it is easier to judge the size of the head once the body is painted. Beginners almost always paint the head too big, so take care.

16 Finish the figure by adding the staff.

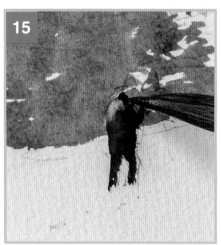

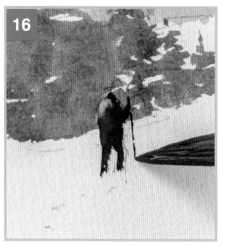

Tip

With small figures in a painting you really only need to think about proportion and gesture. Don't worry about detail, as this would draw too much attention to the figure.

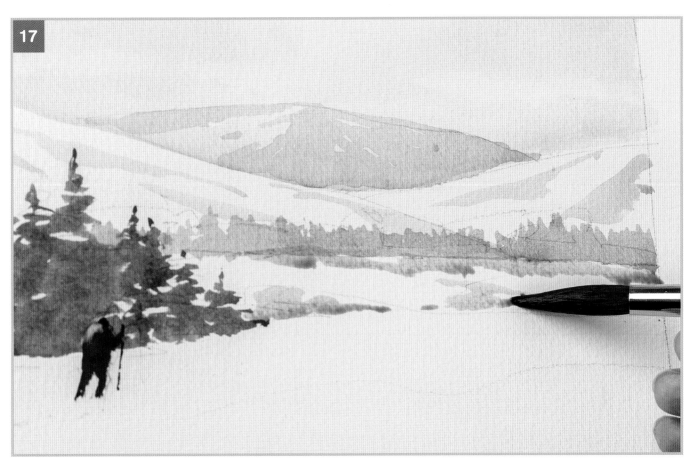

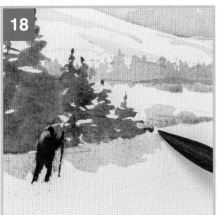

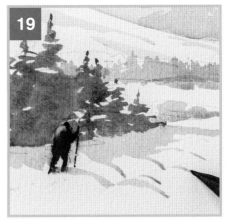

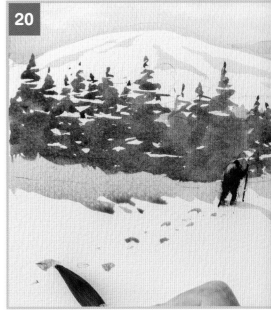

17 Using a cobalt blue mix, touch in some simple shadows on the distant field.

18 Continue to add shadows in the near field, initially painting the cast shadows from the trees.

19 Extend the tree shadows in places with some undulations to hint at the mounds of snow and add the shadow of the figure at this time too.

20 Suggest some footsteps in the snow with a few dots of the cobalt blue mix. The footprints should increase in size towards the foreground of the painting.

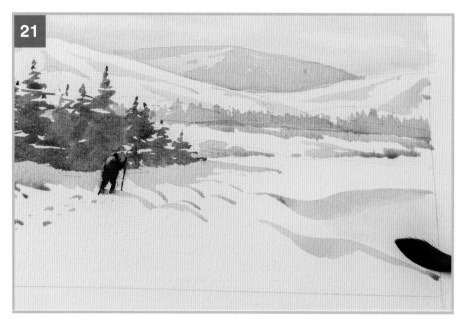

21 Complete the shadows with bigger strokes of varied width as they get closer. The diminishing size of the shadows as they recede is a powerful indication of depth.

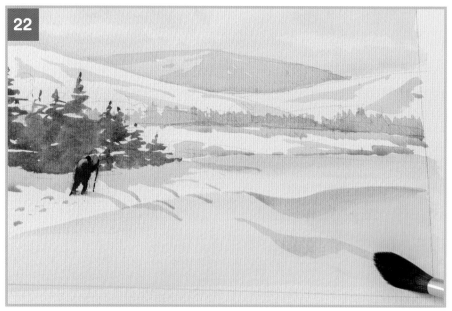

22 We want to avoid too much coolness, so add a little warm ochre colour mixed from quinacridone gold and Winsor red to the near field. Don't cover all of the paper but instead use these strokes to further strengthen the suggestion of the snow banks. Note that this warmer colour helps to bring the foreground closer, enhancing the sense of depth.

JARGON BUSTER

Ochre covers a wide range of colour, ranging from yellow through red to brown. The colour was originally extracted from natural deposits of rock in places like Roussillon in France, but today most is produced synthetically.

These final paintings will appear to have a more complex structure but really it is all about refining the basic techniques. We will move on now to a cottage in the snow.

Winter Cottage

What you learn:

- **Creating puddles in the snow**
- **Snow-covered roof**

1 Use the finished painting on page 57 and the tracing guide on page 64 to transfer the outline to your paper. Secure your paper to your board. We will be using quite a variety of colour here, but the variety is achieved by allowing a small number of colours to blend together on the paper rather than creating lots of separate mixes.

2 We will use the wet-in-wet method for this sky. Pre-wet the sky area with clean water using the wash brush, then immediately drop in some fairly strong cobalt blue mix, as well as a little quinacridone gold and Winsor red mixed to give a pale yellow and a golden colour. The colour needs to be stronger with wet-in-wet because it is immediately being diluted by the water on the paper. Tilt the paper back and forth to allow the paint to flow.

Tip

If the colour doesn't flow when the paper is tilted you haven't wet the paper enough. Fix this by immediately spraying the area with water.

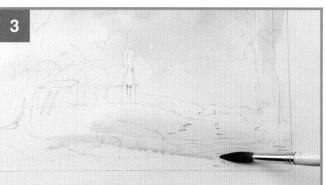

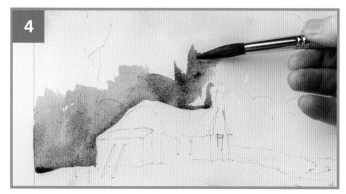

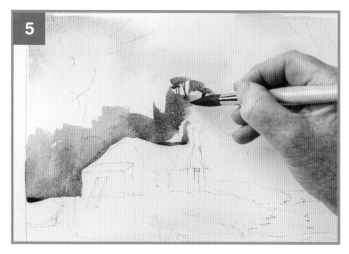

3 Pre-wet the lower part of the paper and quickly paint in a few horizontal strokes of the golden colour. This is simply to add a little warmth in the foreground. Allow to dry.

4 Start with a blue-green mix of quinacridone gold and cobalt blue and paint in some simple middle-distance trees. Paint carefully around the cottage but try to keep the wash wet and flowing, and drop in other colours as you go. Use almost any colour – blue, red-brown and grey will all work.

5 Do not make it too obvious that these are trees; avoid too much detail, but paint a couple of branches into any gaps, which can help the illusion.

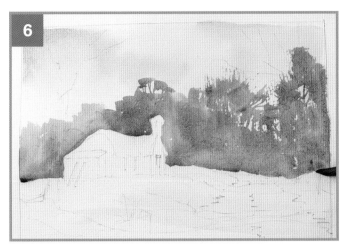

6 Continue across the paper, creating a continuous wash but with variable tree-like colours and just a hint of structure.

7 Paint the building with a warm reddish wash mixed from quinacridone gold plus Winsor red and a touch of cobalt blue. Leave the snowy areas untouched but paint curved rather than sharp corners, to suggest the blanketing effect of the snow.

8 Use the same mix in the puddle, along with a cobalt blue mix to suggest the reflections with vertical strokes. Use your damp round brush to lift off a couple of lighter bands. Think of a barcode – wide and narrow vertical lines.

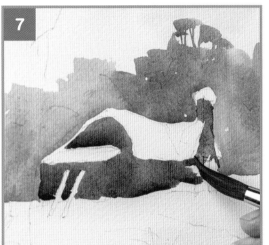

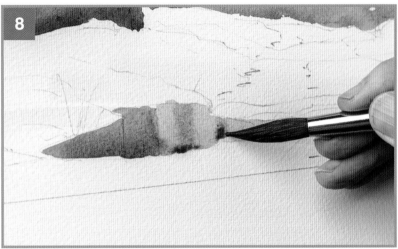

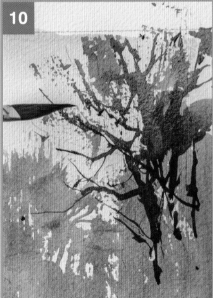

9 For the closer trees, apply some drybrush with the edge of the round brush and the same mix as for the building but with a little more cobalt blue. This is a rapid way of hinting at the smallest twigs at the outside edge of the tree.

10 Use the swordliner to paint in a few more defined twigs and branches as you advance down the paper.

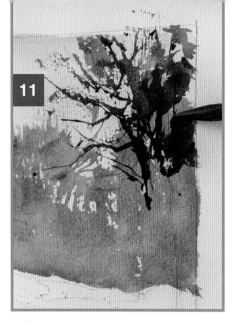

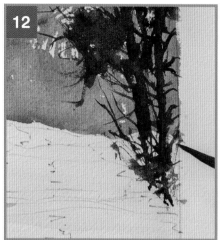

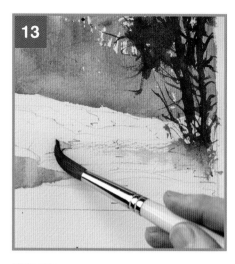

11 Use a combination of broader strokes with the side of the round brush and more detailed suggestions with the swordliner.

12 At the bottom of the tree, allow the paint from the two trunks to merge.

13 With a cobalt blue mix, use the round brush to pick up the wet area at the bottom of the trees and draw it across the road, but do not paint into the puddle. Although technically a shadow can be cast on water, it is only generally when the water is murky and the light is in a particular direction. By stopping the shadow at the puddle, the illusion of water is enhanced.

14 Indicate the door of the house with a little Winsor red and paint the shadow under the eaves and the windows as a single connecting wash using a blue-grey mixed from all three colours.

15 With the cobalt blue mix, work on the shadows. In general, paint these marks to mimic the surface, across the road and up the bank; paint the more distant shadows with thinner and slightly paler strokes.

16 As you come closer to the foreground, strengthen the mix, but take care to avoid painting over the puddle.

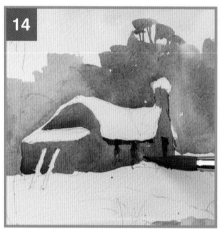

Tip

Always vary the strength of colour used to paint tree branches, or they can look two-dimensional.

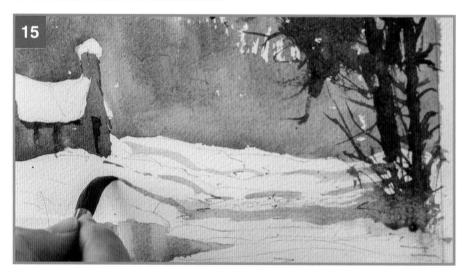

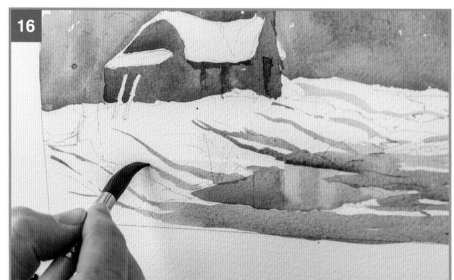

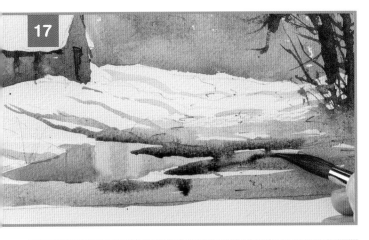

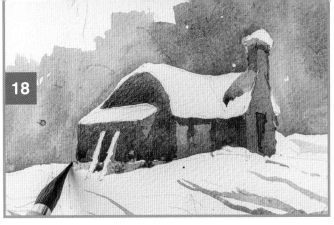

17 Add more cobalt blue to darken the wet shadows around the puddle. This has the effect of showing the light water much more clearly.

18 Paint the shadows on the building and ground using the same dark shadow mix.

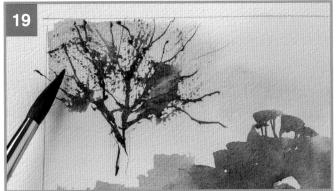

19 Paint the left-hand tree in a similar way to the right-hand one. Make this tree more sparse, with more definite twigs and branches; begin with both the round brush for the drybrush and the swordliner for the twigs.

20 Once the crown of the tree is painted, continue down the left-hand side of the trunk. Vary the colour of the mix – start with a basic grey mixed from all three colours but add little variations as you paint. While the left-hand side is still wet, draw your damp round brush down the right-hand side.

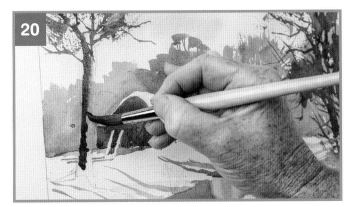

21 On this occasion, the dark has merged a little too much; use the edge of your wash brush to lift off a little paint if you need to.

22 While the trunk is still wet, paint some side branches using the swordliner. Take the opportunity to allow some branches to pass in front of the building to create a distinct overlapping shape.

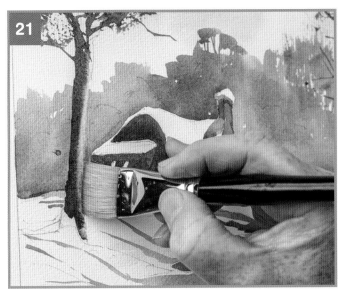

Tip

Overlapping shapes are one of the strongest indications of depth. Always take the opportunity to overlap distant objects with closer objects.

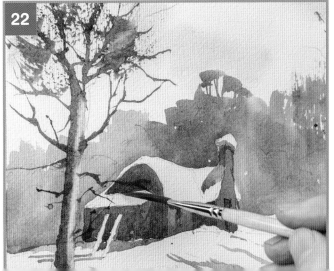

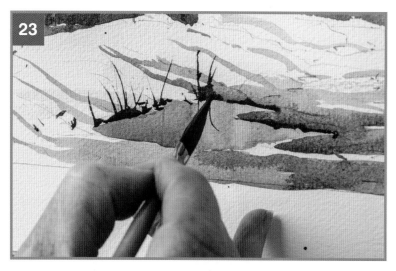

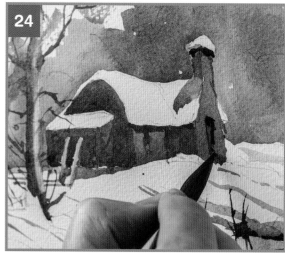

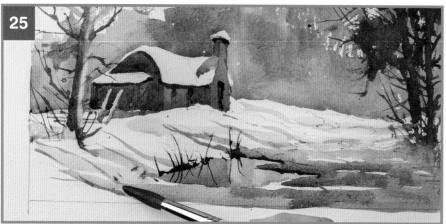

23 Add a touch of warm brown (mixed from quinacridone gold and Winsor red) to the leaning beams next to the cottage. Mix a rich dark with all three colours and use this with the swordliner to darken the far edges of the puddle. This suggests the fact that the puddle is in a depression. Conversely, do not paint the near edges, as these would not be visible in a depression. A few strokes of grass can also be applied elsewhere in the foreground to increase the contrast against the snow; add their reflections into the pond.

24 Use the same mix to add a little extra dark to the edge of the recessed door.

25 Enhance the warm areas at the front with a few strokes of a quinacridone gold and Winsor red mix. Don't forget to follow the shape of the ground.

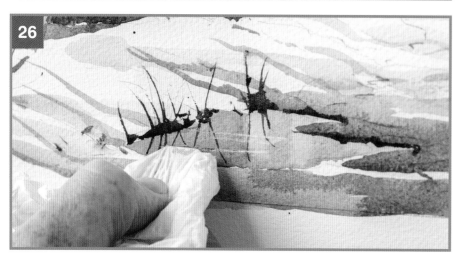

26 Using a damp tissue folded around a credit card, lift out a few light reflections in the puddle.

27 Follow this with a few darker horizontal ripples to further add to the suggestion of reflections.

Although the colours in a snow scene are reduced, in reality the tones are often more varied. We will look more at this important consideration in our final painting.

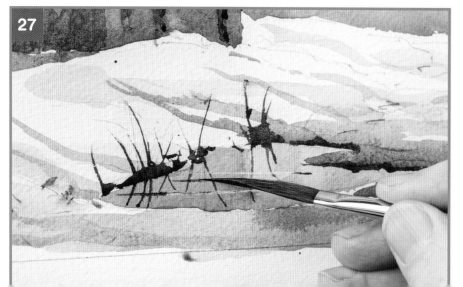

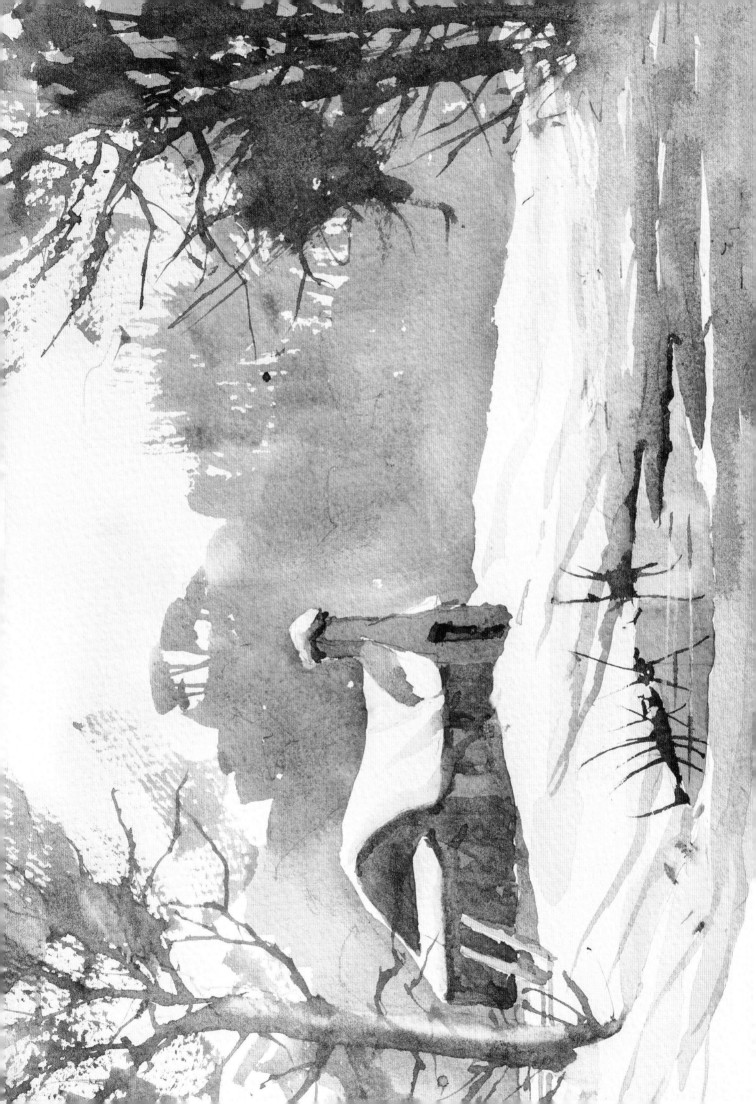

Vermont Landscape

What you learn:

- **Using darks to create the impression of light**
- **Painting negative shapes**

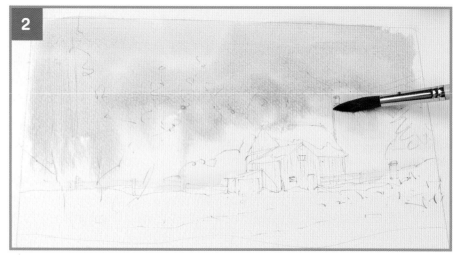

Tip

A dark wash will cover a light wash, so there is no need to waste time painting a light wash around an area that will eventually be dark.

1 Use the finished painting on page 63 and the tracing guide on page 64 to transfer the outline to your paper. Secure your paper to your board. For our final painting we will use plenty of gold mix (quinacridone gold and Winsor red) for the warm areas and, again, we will need a lot of colour variation in the mixed background trees. The dramatic red roof will give plenty of punch.

2 Start the sky with a mix of cobalt blue over the top left and allow the gold mix to blend as you paint down to the far edge of the field. Do not stop at the trees. These must be painted over the sky so that the sky colour is visible through any gaps.

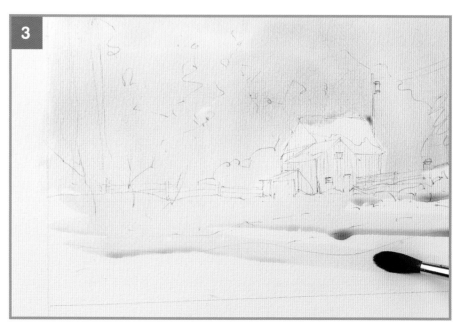

3 At the edge of the field, paint a few horizontal bands of gold to create an overall warmth.

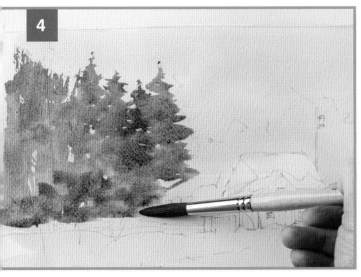

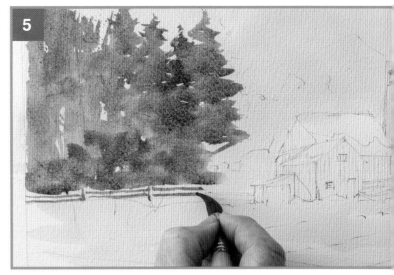

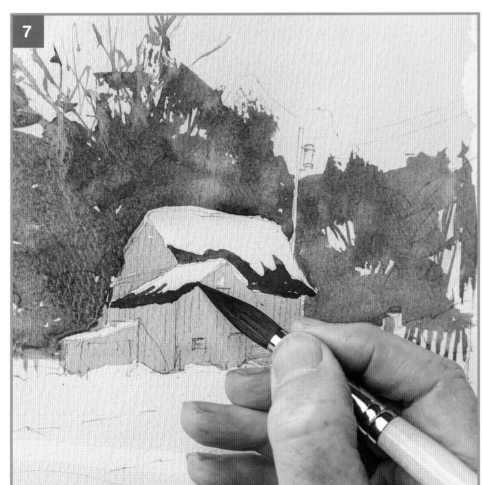

4 The trees on the left are conifers; those on the right are broadleaf. Using variations of a green mixed from quinacridone gold and cobalt blue, paint the conifers to roughly halfway across; use your round brush.

5 Instead of painting right down to the field, use your green to negatively indicate the fence by painting the gaps between the wooden rails.

6 Continue across the paper, painting around the barn. Change to a warmer grey-blue-brown colour for the broadleaf trees (green would suggest leaves). Avoid the telegraph pole and, as for the left side, use negative painting to indicate the gate and fence. You may need your swordliner to indicate branches.

7 Wash over the walls of the barn with a flat brownish wash mixed from quinacridone gold and Winsor red. If it is too orange, add a little cobalt blue. When the walls are dry, paint the lower part of the barn roof with Winsor red, leaving soft curves to suggest the snow.

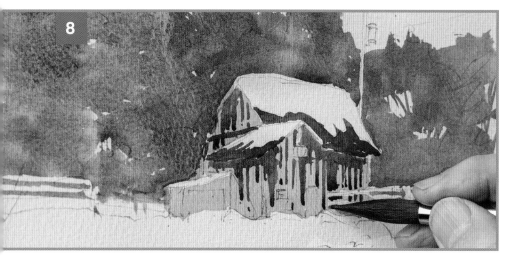

8 Strengthen the wall mix and add a touch more cobalt blue. Use this to paint some of the planks on the walls. Don't overdo this. Cover only around half of the wall area so that there is still some light left from the earlier wash.

9 If you forgot to leave the telegraph pole, or you need to make it more distinct, lift it out now using the edge of your clean wash brush and a gentle to-and-fro scrubbing motion.

10 Paint the top of the pole with a darker grey and your round brush, to give the light-over-dark and dark-over-light effect.

11 Add the transformer and paint the lines with the tip of your swordliner and using the same mix.

12 Paint some cobalt blue shadows with the round brush across the far end of the field. Don't use a solid thick line – break it up to suggest the unevenness of the snow.

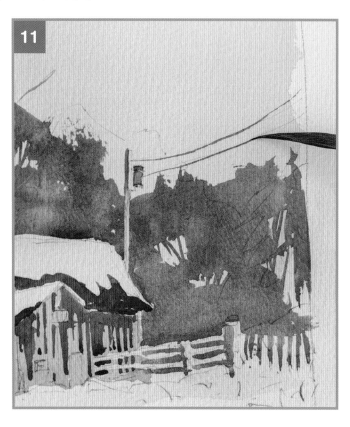

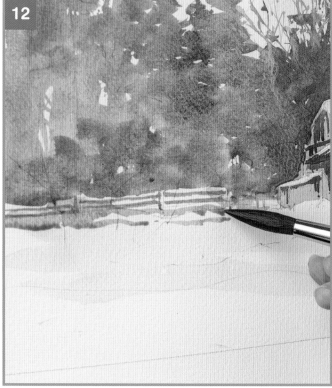

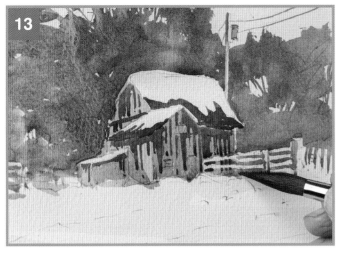

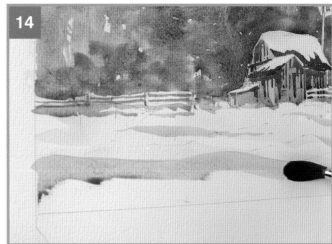

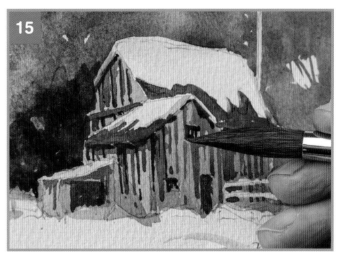

13 Continue over the shaded parts of the barn and over to the right-hand edge of the paper.

14 To create a sense of perspective, add some broader shadow lines as you move down the field, but keep the undulating motion when making your marks.

15 Paint a shadow at the right-hand edge of the fingers of snow on the roof with a thin cobalt blue mix; this will help to show that the snow is quite deep. With a darker brown mix (cobalt blue and Winsor red with a touch of quinacridone gold), suggest some darker trees behind the left-hand side of the barn, to enhance the sunlight on the barn. Continue with this mix to paint some of the planks, but only cover about half of the previously painted planks. You should now have some light areas, smaller medium areas and a few darker areas, which is perfect. It is the variety of tone that gives a painting interest.

16 Continue with the dark mix to paint the ridges on the roof, a few tufts of grass and some darker edges to the fence.

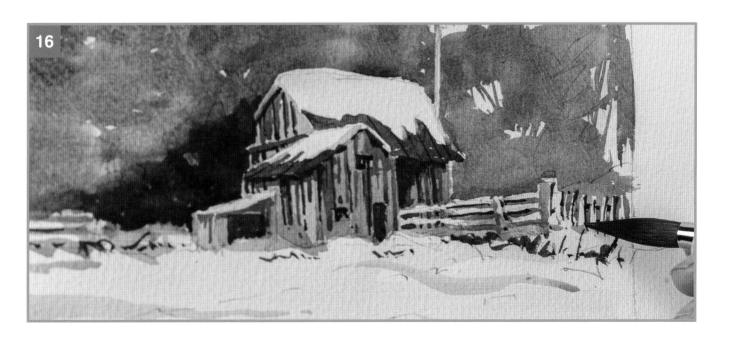

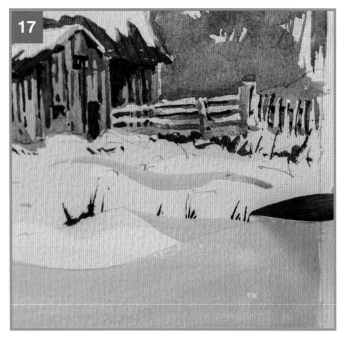

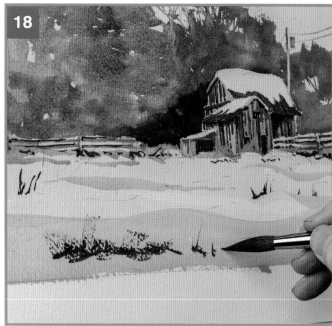

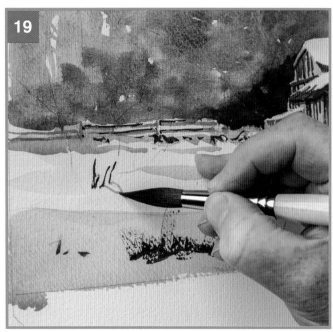

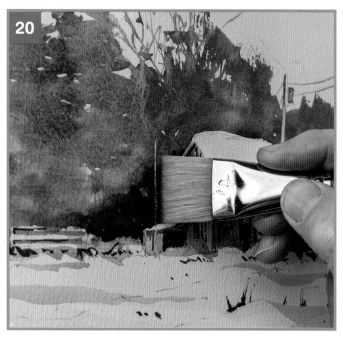

17 Add a few more grassy tufts, but don't overdo it. These tufts are quite fun to paint and it is so easy to just paint a few too many!

18 Add a few further grasses with a different texture. Here, I have used the side of the round brush to give a drybrush effect.

19 Add little cobalt blue shadows where you have painted the more obvious tufts.

20 Finally, use the edge of the wash brush to lift out another vertical pole from the darker trees.

Tip

Try for light, medium and dark tonal areas in most parts of your painting. This will greatly enhance the contrast and therefore the impact.

A typical winter landscape without snow can be painted as a snow scene. As you add it, think of the snow as a white blanket lying softly on the landscape.

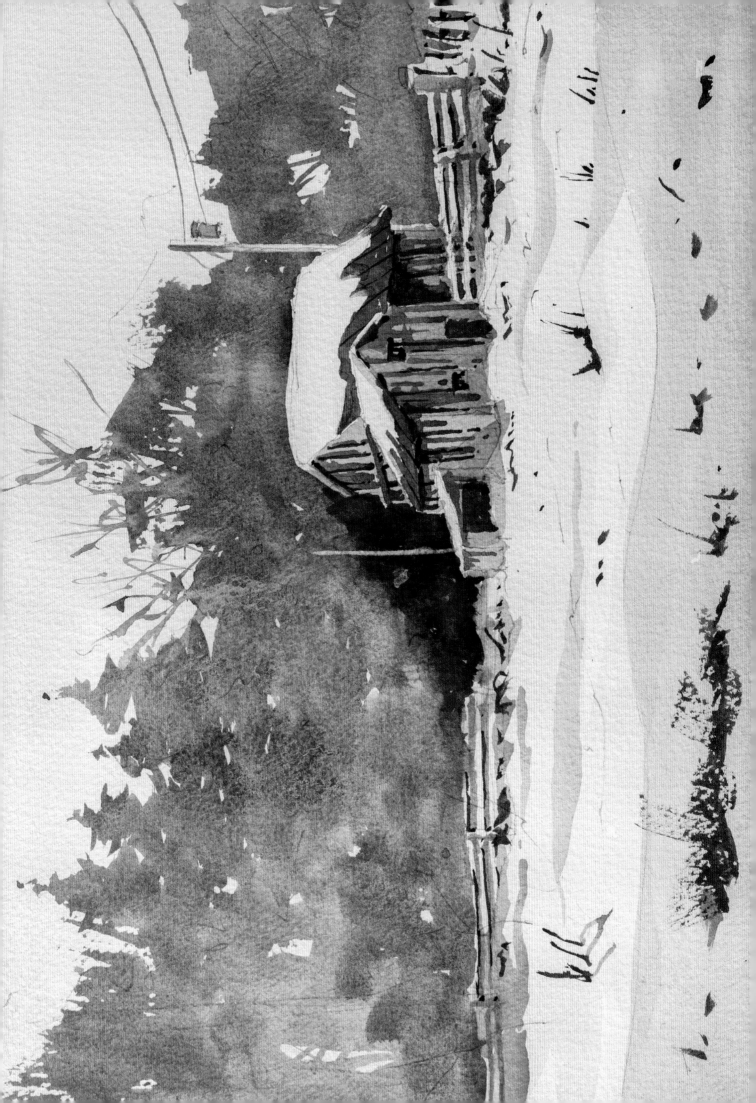

Transferring a drawing

You can trace the drawings from the paintings in this book, as they are shown full size (216 x 290mm/ 8½ x 11½in), and transfer them to your watercolour paper using the method shown here.

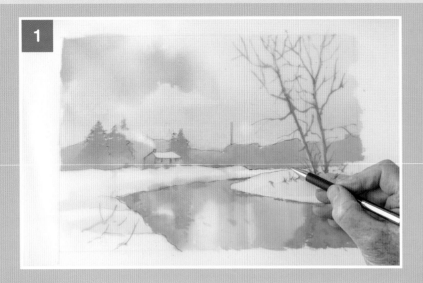

1 Place tracing paper over the image and fix it at the top only with masking tape. Use a medium-hard pencil to trace the main lines of the drawing, as shown.

2 Remove the tracing, turn it over and scribble over the back of the lines with a soft pencil.

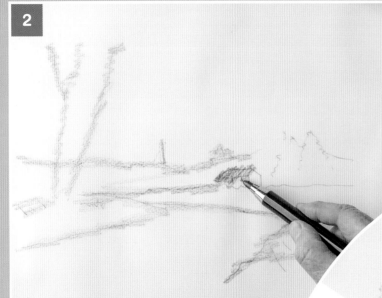

3 Tape the tracing to your watercolour paper and draw over the lines again with your medium-hard pencil. The pencil pressure will transfer graphite from the scribbling onto the watercolour paper. The image might not be perfect and you may need to re-establish some of the lines, but it will function as a drawing ready for painting.